Self-Portrait

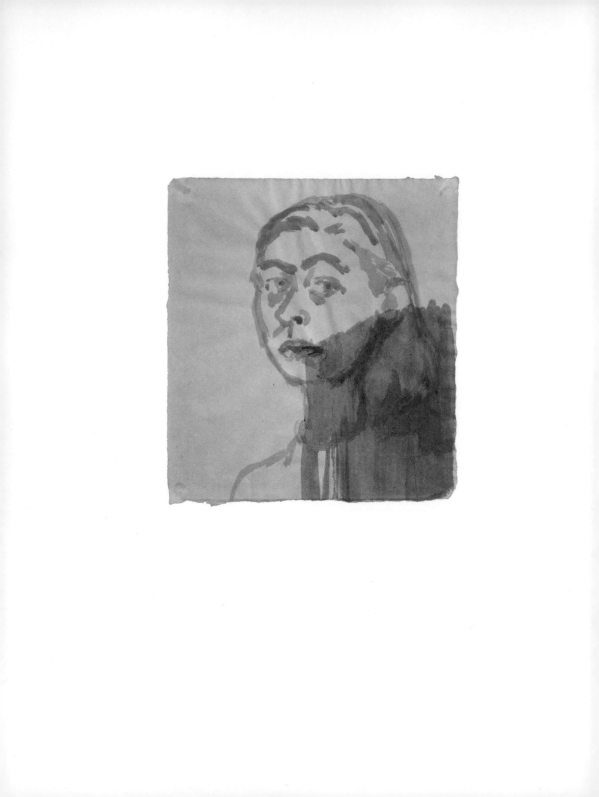

Self-Portrait

Celia Paul

NEW YORK REVIEW BOOKS

New York

THIS IS A NEW YORK REVIEW BOOK
PUBLISHED BY THE NEW YORK REVIEW OF BOOKS
435 Hudson Street, New York, NY 10014
www.nyrb.com

Library of Congress Cataloging-in-Publication Data
Names: Paul, Celia, 1959– author.
Title: Self-portrait / by Celia Paul.
Description: New York : New York Review Books, [2020] | Series: New York
Review Books
Identifiers: LCCN 2020000920 (print) | LCCN 2020000921 (ebook) | ISBN
9781681374826 (hardback) | ISBN 9781681374833 (ebook)
Subjects: LCSH: Paul, Celia, 1959– | Painters—Great Britain—Biography.
Classification: LCC ND497.P363 A2 2020 (print) | LCC ND497.P363 (ebook) |
DDC 759.2—dc23
LC record available at https://lccn.loc.gov/2020000920
LC ebook record available at https://lccn.loc.gov/2020000921

ISBN 978-1-68137-482-6
Available as an electronic book; ISBN 978-1-68137-483-3

Printed and bound in China by C & C Offset Printing Co., Ltd
1 3 5 7 9 0 8 6 4 2

For Eve Pamela

Contents

Prologue 1

Lucian 15

Linda 29

The House Where I Was Born 43

Lucian 51

Home 121

Being a Mother 139

My Mother 155

My Sisters in Mourning 177

Painter and Model 189

My Studio 193

List of Illustrations 207

Acknowledgements 211

Prologue

I'm not a portrait painter. If I'm anything, I have always been an autobiographer and a chronicler of my life and family.

I have told my life in images. I am drawn to painting because the process of painting has always had meaning for me. It has the quality of a live performance, with all its unforeseen risks and the knowledge that what you do can never be exactly repeated. If you destroy a painting in order to go deeper, there is no way you can bring the lost image back to life again. I am attracted to painting rather than to sculpture, say, because an object in the middle of a room or space, however powerful, is no match for the intensity of focus demanded by a painting fastened to a wall.

When I was a young woman I kept a diary. I wrote down my thoughts and feelings, mostly about Lucian Freud, with whom I was in a relationship. I was eighteen years old when I met him and I was twenty-eight when I officially split up with him, though we were to remain connected until his death, through our son, Frank Paul, and through painting. In the diary my thoughts and feelings are written down in prose that is highly charged and often overwrought. Threaded through

this turbulent prose are a few poems. The poems served the purpose of rising above the chaotic emotion, giving a bird's-eye view and distance, allowing the possibility of giving a shape to the chaos and perhaps to create beauty, too. The poetry formed a bridge towards the unspoken language of painting. I could distance myself from the written word and make a new painted language for myself. Painting gave me freedom of speech. Gradually painting took over from the prose, the poetry and from any words at all.

After Lucian's death in 2011, I did a painting titled 'Painter and Model', a reference to Lucian's last painting of me with the same title. In Lucian's painting I am standing, with a paintbrush in my hand and treading on a tube of paint. On the sofa in front of me is a naked man: my friend, the writer and artist Angus Cook. The traditional gender roles are reversed and I am represented as being the painter and Angus is represented as my subject, or object of desire. In the first painting Lucian did of me, 'Naked Girl with Egg', I had lain on the bed in his studio, my eyes turned away from his scrutiny; and in subsequent paintings he did of me my eyes were downcast and I was meekly 'there', for him to do whatever he wanted with me. In this last painting Lucian did of me, my eyes are still downcast, but they are focused on the task of painting.

In my own 'Painter and Model' painting, I have it all. I am both artist and sitter. By looking at myself I don't need to stage a drama about power; I am empowered by the very fact that I am representing myself as I am: a painter.

*

I only ever work from people and places that I know well. This insider knowledge gives me freedom to take liberties with the forms and structures of the faces and figures, the clouds, the waves, the houses. When I don't know a subject well, I am much more literal in my attempt to represent them: I need to get the distance between their nose and mouth, the shape of their forehead right, in order to try and get a likeness. If I know my subject well, it's almost as if I don't need to look at them in order to give them intense attention, and yet I need their physical presence.

The act of sitting is not a passive one. All my sisters – Rosalind, Lucy, Jane and Kate – have their own relationship with the act of sitting.

My sister Kate, who is the most regular of my sitter-sisters, has written about how, when I first started to paint her, I would allow her to read a book, and that I only took the book away when I needed to paint her hands. These first paintings of Kate are wooden and the vital spark is missing. Her understanding of how important it is to give herself to the experience of sitting has made the later paintings I have done of her come alive. I have done a series of paintings of her dressed in white. I imagine them hung in a long line in a gallery space, and I imagine the strong sense of peace that emanates from them. Kate became my main sitter after my mother became too old and frail to climb the eighty stairs to my studio. My mother had an instinct for what it takes to be a great sitter, from the start. It became her 'vocation'. She often used the time for prayer.

I painted my son, Frank, regularly when he was little and then he refused to sit for me when he became a teenager. He sat for me again in his mid-twenties. He finds the silence of my studio oppressive and so, when he

sits, we listen to audio books. I think my paintings of Frank have a different energy for this reason: there is a lightness and freshness to them.

My husband, Steven Kupfer, prepares himself the night before he sits. He used to think about philosophy when he sat for me, but this always made him dream. He would see all sorts of strange forms in my painting clothes, which he was staring at as he thought, and he would soon fall asleep. Now, he memorises cryptic crossword clues the night before and solves them in his head as he sits. He has a ritual for the morning of sitting sessions. He gets up early and travels from his house in Kentish Town to Russell Square, where he is always the first person to arrive at the café in the square. He then reads philosophy for a while before it is time for him to arrive at my studio in Great Russell Street. In winter I feel the cold travelling up with him as he climbs the stairs to my studio, and it takes him a long time to thaw out. He likes the challenge of it all, and his ritual is part of the pleasure he takes in sitting. I think he needs his participation to be 'active'. He is much more aware of his surroundings, and of me at my easel, and doesn't drift off into his own world, like my female sitters do.

I have noticed that the men I have worked from are interested in the process of painting and in the act of sitting. The silence, when I am working from men, is less interior. Women, in my experience, find it easier to sit still and think their own thoughts, and they often hardly seem to be aware that I'm there in the same room. For this reason I usually feel more peaceful when I'm working from a woman, and more free.

I found sitting for Lucian challenging in a different way. He didn't like me going off into a world of my own. He wanted active participation. He would talk and ask me questions while he painted. He liked to watch

his sitters in movement; he liked to watch how the mouths of his sitters were shaped by smiles or speech. He was more of a 'portrait painter' in this way than I am. I would have preferred to think my own thoughts and be peaceful, but he wasn't having any of that!

Since I started to write again my paintings, which are so private and personal that there's almost a 'Keep Out' sign in front of them, have begun to open out. I feel a new assurance in my painting, through a growing confidence about using words again. Through writing this memoir I feel connected to my writing self: the young woman who used words. Memories of that time have become very vivid to me again. Lucian has resurfaced in my mind and my dreams through writing about my memories of him. I feel liberated by being able to put some of my feelings about him into words, and I can see more clearly how my relationship with him developed. I was emotionally dependent on him to begin with, but I became more independent as I became surer of my own talents and direction as an artist. My attraction to the juxtaposition of the mystical with direct observation is so different from Lucian's approach – 'My Mother and God' is an early example of this. Lucian seldom worked from his imagination and he felt strongly that intense concentration from life was the vital thing.

<div align="center">*</div>

One of the main challenges I have faced as a woman artist is the conflict I feel about caring for someone, loving someone, yet remaining dedicated to my art in an undivided way. I think that generally men find it much easier to be selfish. And you do need to be selfish. Ideally you need 'to care and

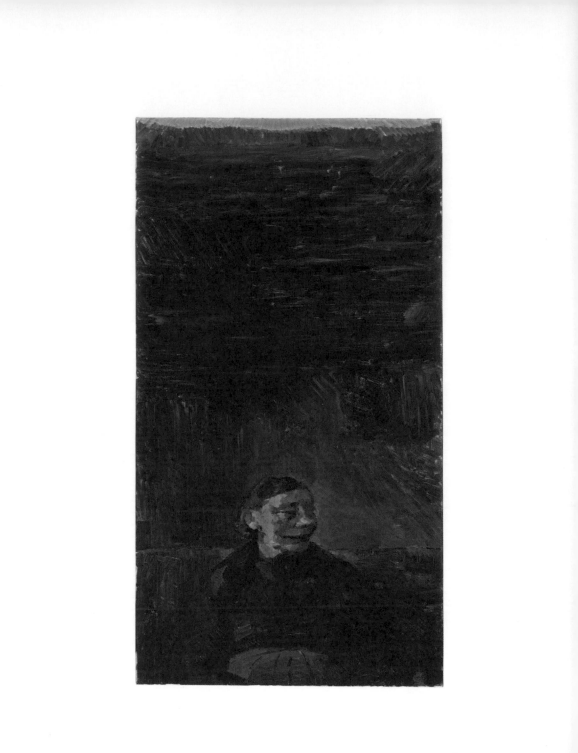

not to care? You need to give yourself completely, while at the same time seeing things from a distance. Every important creative act has this duality: of giving everything and then of letting go, so that the created work can have a life of its own.

I have felt this conflict most painfully with caring for my son. I have had to make my flat/studio a separate space: my work space. When I am with Frank I don't have any thoughts for myself. All my concerns are for him. Therefore I am unable to work when he stays with me. Frank understands and accepts this, and I think I have often found it more painful than he has. In a catalogue introduction to an exhibition that I had at Marlborough Fine Art he writes:

> Isolation is deeply important both to my mum's work and to her peace of mind. Her room is bare except for a bed, a chaise-longue, two chairs and a lamp, as well as the occasional stray daub of paint. Her studio, which no-one else may enter without permission, is a mass of splintered floorboards, paint spatters and canvases, but, like the bedroom, it's devoid of any adornments which others might find necessary for a sense of self-assurance. One might conclude from this that my mum is an entirely self-subsistent person, yet she feels separation keenly, as well as a deep guilt that her need for solitude precludes her from being as hospitable as she would like to be.

Steve and I don't live together because of my need to have my own private space. He doesn't have a key to my flat. He also understands

and respects my need for privacy. He is a very private person, too. His support for me and for my work is without bounds, and so much of my recent confidence is due to his continuing love. His meditative response to my work has helped me, too. When I showed him the first draft of this book, his reaction was immediate and warm: 'There is tenderness in it, and as I've said, generosity, and something more that comes with the recognition that the past with its pains and joys has a place and a voice that the present can and should allow.'

It was a conflict of desire that I suffered at first with Lucian, as well. He spoke admiringly to me of Gwen John, who had stopped painting when she was most passionately involved with Rodin, so that she could give herself fully to the experience. I felt that there was a hidden reproach to me in his words, and that Lucian felt that was what I should do.

I would like this book to speak to young women artists – and perhaps to all women – who will no doubt face this challenge in their lives at some time and will have to resolve this conflict in their own ways. This seems to me to be essentially a feminine dilemma. Throughout history, women have too often been seen as subjects of art, rather than artists. Their natural propensity for giving themselves up to the experience, combined with an aptitude for stillness, has made many women great muses to great male artists. As a woman painter, one needs to work out a strategy: I feel the need to put up barriers to protect my solitude. I agree with Virginia Woolf that the vital thing for a woman artist is 'a room of one's own.'

By writing this autobiography, I am my own subject just as much as in my painting 'Painter and Model.' By writing about myself in my own words, I have made my life my own story. Lucian, particularly, is made part of my

story rather than, as is usually the case, me being portrayed as part of his. I have chosen to use words, rather than paint, because words can communicate more directly. The hermetic language of painting necessarily keeps its secret: its power remains mysterious.

By using the voice of my young self in the notebook entries, and by recording my memories of that time, through the vividness of the past and the measured detachment of the present, I am aware as never before that there is an unbroken connection between the two: I have always been, and I remain at nearly sixty, the same person I was as a teenager, when I first met Lucian; and as a child in India, when I sat so still in the beautiful garden of our house in Trivandrum that the butterflies landed on me. This simple realisation seems to me to be complex and profoundly liberating.

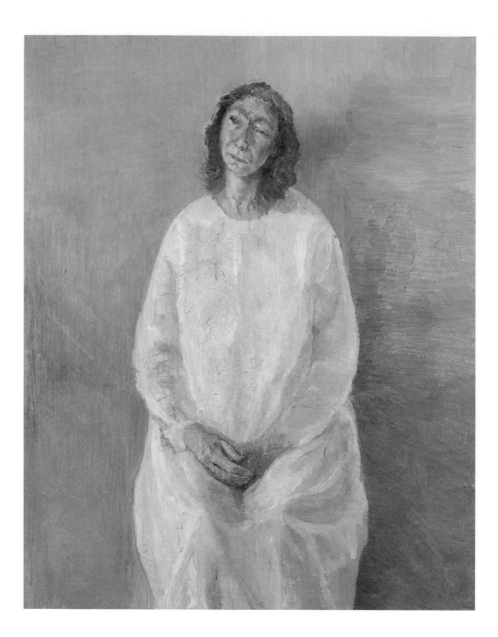

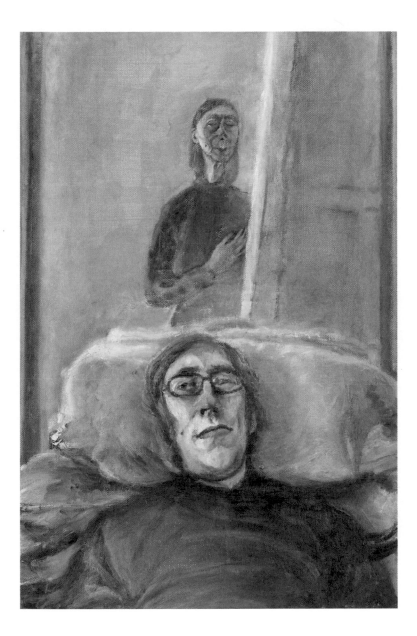

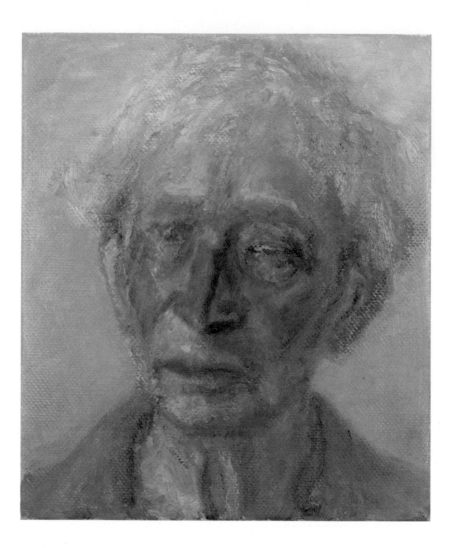

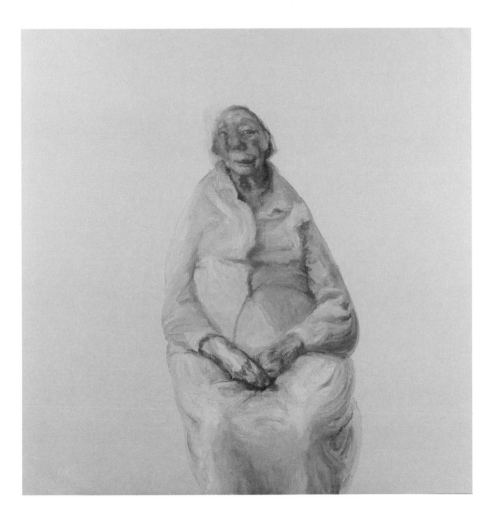

Lucian

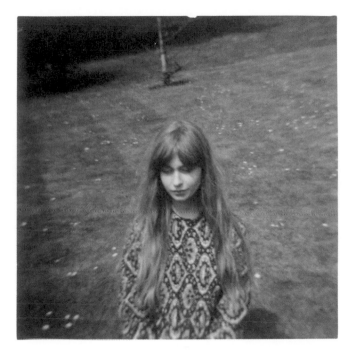

His face was very white, with the texture of wax. It had an eerie glow as if it was lit from within, like a candle inside a turnip. His gestures were camp. He stood with one leg bent and his toes, in their expensive shoes, were pointed outwards. He sucked in his cheeks in a self-conscious way and opened his eyes wide until I looked at him, and then his pupils, which were hard points in his pale lizard-green irises, slid under his eyelids and I could only see the whites of his eyes. On entering the basement studio in The Slade School of Fine Art, he was aware of the dramatic impact of his entrance and he made the most of it. He stared pointedly at the naked model lying on her filthy mattress in the middle of the room and then took a drag on his French cigarette so that his small head, which was crested with hair like the feathers of an eagle, was wreathed in smoke. His hand fondled the white silk scarf that plumed his neck, and then adjusted the lines of his immaculately tailored grey wool suit.

After his great stage entrance, he seemed to forget his lines and didn't know what to do with himself. I helped him out by prompting him. I went

up to him and asked him if he was busy. He was amused by my question and tilted his head and smiled shyly. I showed him the charcoal drawings I had done of my mother: the backs of her knees, with the tender little line at the crease; her feet, with the beautiful toes already beginning to show signs of their later crookedness; her legs with their familiar large thighs; her head flung back; the tenderness of her smile.

His voice was gentle, almost a whisper, and he had a foreign accent. As he stood by me, he shifted his slight weight from one foot to the other and glanced sideways at me like a frightened bird. I showed him the large florid oil portrait of my father, who had been so flattered by my depiction of him that he had had the portrait framed in wood and had painted it gold, with some paint that he had bought from W. H. Smith's. I had made him wear his episcopal cloak flung around his shoulders, his eyes were looking down, and swirls of stormy paint circled his white-haired craggy head. He looked like a hero in a romantic novel or poem. Lucian admired the painting and said that 'aesthetically' the gold frame suited it.

I was wearing a dusty bottle-green, long corduroy dress, which had a bow at the back. He touched my back, just below the bow, and said that it would be nice to go for tea. He followed me out of the studio and we walked through the maze of underground corridors, dark and smelling of detergent and turps, to the refectory of University College London, where we each got ourselves a cup of tea from the machine and sat facing each other over one of the long, narrow refectory tables. He talked to me about the paintings he was working on: a series of night nudes, and the big painting he was working on by day. The daylight painting was of two plants. He said that the plants kept changing all the time, shooting out new leaves, so that he was constantly

having to repaint it. I said that it must be like painting a constellation. He politely agreed that it was. I said that I would love to see it, and he took that to mean right away. This time I followed him.

We went up the dark stairs and out into the bright October sunlight. First of all he wanted to buy himself a book about the brain, which Francis Bacon had recommended to him, from the medical bookshop on the corner of Gower Street, and then he hailed a taxi. As we drove west the low autumn sun was blinding. He took my hair and wound it around his fingers and started stroking my throat with a soft rotating movement. I felt his knuckles on my throat through my hair. He stared at me fixedly and told me I looked so sad. He asked me for my phone number, but he didn't have anything to write with. He found an envelope in his pocket and took out a huge clump of keys on a key ring, the sharpest of which he used to scratch my number on the envelope.

The taxi drew up outside an impressively tall house, white like a wedding cake and one of a curved line of similar houses, all facing Holland Park. We went up the wide carpeted stairs until we reached a door like a wall, covered in mouse-coloured baize. He took out his bunch of keys and unlocked the door to reveal another door, which he unlocked with a different key. As the door opened I could see the hallway, with a statue of a pot-bellied naked man in the centre striding out to meet me like a welcoming host. He introduced me to the statue by telling me it was Balzac by Rodin. A delicate chandelier hung above Balzac's massive head. We went into the large white kitchen on the left. The trees of Holland Park formed a frieze outside the windows. He made lapsang souchong tea, which we drank out of wide white china cups. As I was drinking it, he came and stood behind

me. He lifted up my hair and buried his face in it. He asked me if I had read the poem by Baudelaire, 'La Chevelure' (The Head of Hair). '"*Nage sur ton parfum*" – swimming in your perfume, the scent of hair … rather good, don't you think?' he murmured.

He pulled me gently but insistently into a standing position. I watched him kissing me and my mouth was unresponsive. I saw the whites of his eyes and he looked blind. His head felt very small and light as eggshell. I was frightened. I asked him what he thought of my work. He said that it was 'like walking into a honey-pot'. He then gently led me into the studio. The painting of the two plants was on the easel. One area of the canvas was highly charged with paint marks depicting the small, more elaborately leafed of the two plants. The round, slightly furred leaves, green as they renewed themselves, and hiding behind them their desiccated brown ghosts. Already the painting was obsessive and gave the sense of nature endlessly renewing itself. Bursting through this dense pattern of leaves were the beginnings of the shiny aspidistra.

He started to kiss me again, but I was insistent that I had to go back now. I told him that I had arranged to meet up with a life model, who I hoped would be able to sit for me privately. As I was leaving I noticed a beautiful unfinished painting by him, which had been framed and was hanging by the door. It was of a woman with her head resting on one side in a dreamy reverie. Her mouth was half-open. The image was full of love. When I was halfway down the stairs I heard him calling after me in a gentle voice, 'Thanks awfully.'

*

Lucian Freud had been asked by William Coldstream, the previous Slade Professor, to be a visiting tutor. He was supposed to come into The Slade every Tuesday afternoon. The day before my first encounter with him there had been an air of great excitement at The Slade. I was living in a basement room in the UCL chaplaincy in Woburn Square. I was eighteen years old and I had already been at The Slade for two years. The chaplain had offered me a change of room that year, on the top floor overlooking the treetops of the square. He thought that I needed light for my painting. But I preferred to be secreted in my basement room, far away from the other students. I cooked my meals on a Baby Belling because, I explained to the chaplain, I needed to be alone. The chaplain had recently informed me that I should soon have to leave my room because I no longer went to church (one of the requirements for living there). So I had found myself a room close to where I had lived when I first came to The Slade, in Notting Hill. I would move there in January. Meanwhile that autumn term I went every day to The Slade, to another basement room: the studio where the life model lay on a mattress or, in the case of the male life models, stood for long hours in complicated positions to test their endurance, and mine.

The emphasis on life drawing at The Slade had turned my attention away from nature and towards people. I couldn't understand the principle of life drawing. It seemed so artificial to me to draw a person one didn't know or have any involvement with. Surely art was about recording a personal vision? I needed to work from someone who mattered to me. The person who mattered most to me was my mother. The drawings that I had shown Lucian at our first meeting at The Slade were the first true works of art I had made, because they were of my mother. They were necessary because I loved her. Their necessity gave them their force.

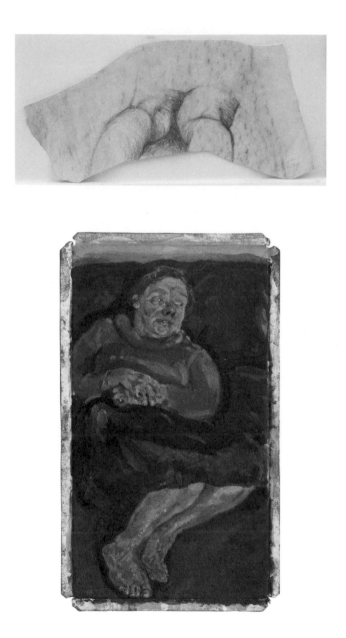

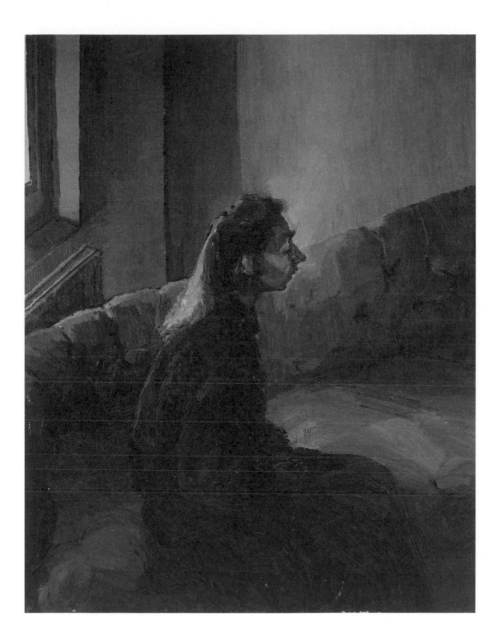

When I first met Lucian, my parents and my younger sister Kate were living in Hull. I had started to paint the elderly ladies in the old people's home nearby. I was moved by their stillness and resignation. Gradually my mother became my main sitter. I started to work from Kate, too, as I still do, forty years later.

I had seen Lucian's paintings reproduced in a book of British art at Lee Abbey in Devon and I thought they had an affinity with Dürer. More recently, in the spring term before I met him, I had seen his exhibition at the Anthony d'Offay Gallery in Dering Street. There were portraits of his mother, among portraits of a big man with his meaty hands on his knees and portraits of naked friends and daughters. The paint was raw and thick, and the figures were awkwardly placed on the canvas. They no longer reminded me of Dürer. They felt very urgent. The paintings of his mother stayed in my mind. I felt connected to him through the deeply personal quality of his art.

The Tuesday following my first encounter with Lucian I decided not to go into The Slade. I was afraid of him and reluctant to see him again. Instead I hired a fat French-Algerian septuagenarian ex-cabaret dancer called Madame de Bara to sit for me. I had stretched a huge canvas, which I put on an easel in the tiny, disordered room. Madame de Bara sat in front of the dusty window, which looked out onto a little underground area covered with rubbish and the rotting remains of a pig's skull; I had bought a pig's head from the butcher's so that I could paint it, and now the smell of decaying pig flesh mingled with the smell of Madame de Bara's flesh, which she had sprinkled with strongly scented talcum powder. She had dyed her hair black and it formed a matted frizz around her puffy face, on which she had painted

her eyebrows in two surprised arches. She looked a bit like the lion in the film of *The Wizard of Oz*. She was a kind, motherly person. She explained to me that she had 'one cataract' and would soon need an eye operation. She was anxious about her son, who was fighting in the war (I never gathered which war). She told me that she thought I was a real painter because of the still way I looked at her, but that sometimes I went off into a dream and then she felt I should concentrate more.

That evening I was reading quietly in my room, but was interrupted by a knock on my door. One of the students said there was a man on the telephone for me. I went upstairs to the payphone in the hall, next to the chaplain's room, and picked up the receiver. I heard Lucian's familiar German half-whisper on the phone.

'I waited for you.'

I explained that I had been working on my own, and that's why I hadn't been into The Slade that day.

'That's very good,' he said. And then, 'I would love to see you.'

I felt tangled because he made me nervous, but I suggested meeting him in Regent's Park the following afternoon. I had walked there a few days before and thought how freeing it was to see grass and trees again. We lay on the grass and watched the gulls pecking at the earth and Lucian said, 'Those gulls have never seen the sea.' I was wearing an Indian wraparound skirt, which he untied, and he started to kiss my waist. I felt very sad, also unnerved. He seemed lonely and needy and strange. He had bought me a big book of Michelangelo sculptures. On the cover was a close-up of the head of the Virgin from the Rome Pietà. Lucian said she reminded him of me. He asked me if I would see him the next day and I said yes.

The pockets of my coat were heavy with coins as I climbed the stairs to his flat in Holland Park: I didn't own a handbag. Lucian was waiting for me at the top of the stairs, half sitting on the bannisters and tilting his head in his habitual shy way. Once I was inside, he pressed me against the wall and started kissing me. He then pulled me onto the ground, and the coins fell out of my pockets and scattered all over the carpet around the base of the statue of Balzac, so that it resembled those statues in the middle of ponds that people throw coins into. I felt hemmed in. I needed to get out. The doorbell rang and I felt very relieved. Lucian went to the intercom and a woman responded to his 'Hello'. He apologised to me and said he had forgotten that he had a visitor coming. He asked me when he could see me again and I said I wasn't sure, but could he ring me? On the way down I passed a fair-haired woman with very blue eyes who looked at me inquisitively. I was amused to think what she would make of all the coins scattered on the hall carpet.

When Lucian rang me at the chaplaincy I arranged to see him the following day after Lawrence's art-history lecture. Lucian had lit a small fire in the grate in the bedroom using paintbrushes as fuel. 'Down with art!' he joked. We sat awkwardly on the floor by the fire. I recited to him 'He Wishes for the Cloths of Heaven' by W.B. Yeats. Lucian said that he preferred Yeats's late poetry. He seemed rather irritated by my winsome prevarication. At last he was able to lead me to the bed. We became lovers.

I was disturbed by the experience. My metabolism seemed subtly changed. I wondered if my mother would notice any difference in me. I stopped brushing my hair or washing my clothes. I felt that I had sinned and that something had been irreparably lost. I felt guilty and powerful. I felt that I'd stepped into a limitless and dangerous world.

*

He Wishes for the Cloths of Heaven

Had I the heavens' embroidered cloths
Enwrought with golden and silver light,
The blue and the dim and the dark cloths
Of night and light and the half-light,
I would spread the cloths under your feet:
But I, being poor, have only my dreams;
I have spread my dreams under your feet;
Tread softly because you tread on my dreams.

Linda

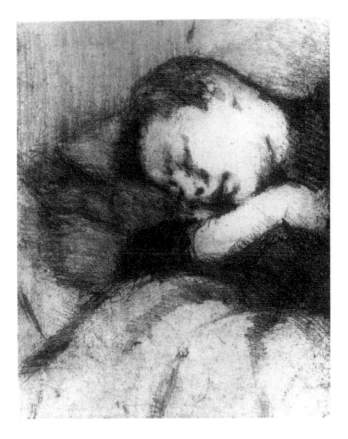

Before I came to The Slade I had been living in Devon, where my father was head of Lee Abbey, a religious community on the Exmoor coast. The beauty of the surroundings had been what inspired me to be an artist, as well as being driven to it by the lack of privacy: we lived in the community and shared our meals with the community members. When we moved there I had been sent to a girls' boarding school, so I had no privacy there, either. Painting became my way of guarding and controlling my inner life.

I found objects on my walks through the woods and on the beach – driftwood, a crow's wing, a wasps' nest, bits of rusted machinery – and I arranged them to form still-lifes. I painted obsessively. Everything became heightened, and I saw things as if they were visions, lit with a lurid light.

I was also driven to be an artist by an intense relationship that I had with another girl at my boarding school.

The boarding school that I and my sisters attended from Lee Abbey was thirty miles away, in Bideford. The school uniform was dark navy, with a cap and cloak to match. The cloak was lined with pale blue. You were supposed

to turn it inside out if you wore it in the dark, so that you would be visible when crossing the road. Not that there were many roads nearby. The school was set above the town. Four boarding houses were grouped around it on the school estate, all large and Victorian. I was in a house called Belvoir.

The gardens surrounding Belvoir were very beautiful and bordered by woodland. A great sweep of well-tended lawn spread out beyond the conservatory and was surrounded on all sides by flower beds. In the summer, enormous irises grew in the border nearest the conservatory and a variety of flowers bloomed throughout the year. Arriving at Belvoir after the Easter holidays, it was always astonishing to see how the cherry tree had burst into blossom in my absence. It should have appeared to me as a sign of welcome, but it didn't. Somehow the sight of it always intensified the melancholy of my return.

I first saw her when she entered the small cloakroom by the entrance hall at Belvoir, where I was hanging my cloak up on the peg assigned to me. I noticed that there was a new name above another peg that I didn't recognise: Linda Brandon. She smiled at me and I felt instantly connected to her. She wore her dark-blonde hair in two thick, long bunches. Her hair was coarse-textured and I could see that she had had difficulty trying to train it through the regulatory elastic bands. Fronds of it stood wildly around her head in an electric nimbus. She had a very wide smile, pinched down a bit in the corners: this slight reining-in of her otherwise free smile gave her a diffident air.

My next real memory of Linda was in the art class, which must have taken place quite soon after this first encounter. We each had a selection of poster paints on our desks, with one or two brushes standing in a beaker of water and

a large sheet of paper. It was the autumn term and the subject for the day was 'Autumn'. I liked painting and drawing. I felt I was good at illustrating some of the Hans Christian Andersen fairy tales that I was fond of: drifty, romantic sketches. But I didn't feel intense about art then. I don't remember my own 'Autumn' painting, but I do remember Linda's. I was astonished by it and felt the first stirring of envy. She had painted from memory some dry, curled-up autumn leaves. The representation of the leaf veins, textures and russet and gold colours was delicately realised. It was a miracle that she wasn't painting from life. She had placed the leaves randomly all over the page as if they had just fallen there. The clean whiteness of the paper seemed incorporated into the design, in order to bring the leaves more sharply into focus. Linda was very quiet as she worked and seemed to know exactly what she was doing. I complimented her on her painting. We became friends.

It felt wonderful to have Linda's friendship. We both loved the same things: poetry and art. We read everything we could that we considered elevating. We both wrote poetry and we drew obsessively. I started to make detailed drawings of the plants and flowers in the garden at Belvoir. When I went back to Lee Abbey at weekends, I would collect seaweed from the beach and make pencil studies of it, to bring back to show Linda. When it came to the summer term, when we were both thirteen, I remember that we lay down in a huge field of buttercups. As we lay on our backs on the ground, the delicate flowers trembled above us and the sunlit yellow reflections darted over us like living things.

But a new powerful undercurrent was developing in my relationship with Linda and it was fuelled by competitiveness and jealousy. We were obsessed with art, and the obsession was making us secretive and mistrustful

of each other. The person who was stoking the flames of our obsession was our art teacher, Miss Bailey.

Her ordinary-sounding name seemed inappropriate. Her mother was Finnish and she had a slight foreign accent. I don't know how she'd ended up teaching in this obscure school. She was built on a gigantic scale. She wore her heavy, dark hair piled up on top of her head and fastened with pins to form a high crown. All her movements were extremely slow. She had an almost permanent sphinx-like smile on her face. She seemed to be looking at everyone and everything from a great distance. Art was the only subject that mattered.

Linda could do a very good impression of Miss Bailey's way of speaking: a slow, heavy drawl accompanied by a flaring of the nostrils and a narrowing of the eyes. Miss Bailey always dressed in black, and she wore heavy bead necklaces and huge, elaborate earrings. She had a habit of laughing quietly to herself while looking at you with a faintly disapproving expression. She provided us with books on Cézanne and El Greco, and she gave Linda and me a key to the art room so that we could work there undisturbed at night, if we wanted.

It was the summer term, and Linda and I were fifteen. She gave us only one key to share. Whoever held the key had power over the other one. If I had the key, I would steal secretly into the art room in the evening. The secrecy of it was extremely exciting. I locked myself in with my key. The smell of paint and the silence of the room were intoxicating. I was working on a painting of a huge poppy. I had set the flower in a glass jar in front of a gnarled piece of wood and I was working on a still-life of it. I was very influenced by El Greco at this time and all the contours flamed and flowed

upwards. The art room faced towards a hill of houses, one of which I knew was Miss Bailey's. I sensed that she was watching the lit-up window of the art room and laughing quietly to herself, as she pictured either Linda or me working feverishly and guiltily in the night when we should have been in our dormitory preparing for bed.

I was beginning to lose myself in my painting of the poppy, its huge, crêpy form rising up from the dry wood like a resurrected spirit, when I heard someone turning the door handle and pushing hard against the door. I knew that it was Linda. I kept very still. She tried the handle again a few more times, and then I heard the sound of her footsteps as she walked away. When I saw her in the dormitory later that night, neither of us spoke of it.

One evening Linda was the key-holder and I was the one who was locked out of the art room. I listened at the door and I could hear the stealthy scratching of her pencil on paper. What could she be working on? I rested my head on the art-room door. I felt overcome by a sort of horror. My feelings were overwhelming, frightening and difficult to define. I couldn't bear the image that I conjured up in my mind of Linda working smugly on her drawing under the watchful eye of Miss Bailey from her house on the hill. I had forgotten that it was a parent–teacher meeting that evening. Just as I lifted my head from the door and was about to walk away, my mother appeared round the corner of the corridor, saw me and cried out, 'Celia!' I felt shocked to see her and couldn't speak. How could I explain to her the nightmare I was in when I couldn't explain it to myself?

Linda and I were in the same dormitory. One morning, soon after five o'clock, I was woken by a quiet scuffling sound. I opened my eyes and saw that Linda was up and dressing herself very quietly. I watched her slipping on her

shoes and tiptoeing stealthily out of the dormitory. I waited a minute, then rushed to the window and looked down at the path that led from Belvoir to the main school. Linda soon appeared, walking purposefully towards the school. I quickly got dressed and headed off in the same direction to see if I could find out what she was up to. I walked quickly and silently up the stairs to the art room. I tried the handle and the door opened easily. I went in. The art room was deserted. Where could she be? I searched everywhere, but couldn't find her. I had to give up and went back to the dormitory. All the girls were up and getting dressed, ready for breakfast. Linda was there, too.

After breakfast I had an idea of what she might have been up to. On the top floor of the school there was a long corridor with a number of doors leading to very small rooms: these were the music rooms. Sounds of scales being played on pianos echoed out into the corridor. One of the doors to the little rooms was half-open. I peered in. A still-life, with a violin propped vertically on a chair draped with heavy patterned fabric, had been set up. There was a finished painting of the still-life on an easel in front of it. The painting was beautiful. A lot of work must have gone into it, because the patterns on the cloth were carefully rendered, vanishing and reappearing in the folds. The violin was freely and confidently represented, with its elaborate shape easily dealt with and all the highlights on its polished surface gleaming. The surge of jealousy I felt was sickening and I thought I was going to pass out. I didn't mention my discovery to Linda. When I saw Miss Bailey praising her for the painting in the art class later that day, I stayed silent.

*

That autumn I had my sixteenth birthday. When I went back to Lee Abbey for the Christmas holidays I placed a big, heavy wooden table in front of my window in the bedroom I shared with Kate. I got lots of pieces of board from a shed behind the main house. I bought oil paint, turps and brushes from the art shop in Lynton: Gunns for Gifts. I scoured the woods and the beach and brought back pieces of wood and broken bits of machinery that I found rusting behind the farm buildings. I brought home all my trophies, and I painted and painted. My room was above the sitting room, and my sisters could hear the table legs creaking as I worked. Sometimes I found their chatter and laughter coming up through my floorboards distracting, and I would drum my feet and bang on the floor to make them quiet. They always obeyed and I had no feelings of guilt at being so bossy and demanding.

When I went back to school after the holidays I had a huge amount of work to show Miss Bailey. I didn't show my work to Linda now. I didn't want her to be inspired by me to work even harder than she did. Miss Bailey was astonished by my productivity. She looked very seriously, and for a long time, at my work. I knew that she was deeply impressed and affected by what she saw. After she had looked carefully at my paintings and drawings she was silent and gave me a long, steady look.

I went back to the dormitory and felt secretly triumphant. When Linda was out of the room, I looked in the locker under her bed. There was a big sketchpad in it, with a half-finished drawing done in heavy black pencil of a dried sunflower head. The rest of the sketchpad was empty. Was that all she'd done over the holidays? I quizzed Linda slyly about how she had spent her time. She said that she'd gone for long walks with the family dog and

that her younger brother had accompanied her. She described some nice meals that her mother had cooked. I sensed, with relief, that her passion for painting was beginning to fade.

Just before the Easter holidays I had a message from another girl that Miss Bailey needed to talk to me. She told me that after she had seen the work I had done during the last Christmas holidays she had been convinced of my talent, and she was certain that I should now dedicate myself to becoming an artist. She had written to Sir Lawrence Gowing, Slade Professor at The Slade School of Art in London, and had now received a response from him. She showed me the letter. The handwriting was big, spiky and right-sloping, in black ink, with no attempt to keep to a straight line: the sentences flowed in a steep diagonal tilt to the right. Gowing invited me to bring my portfolio to The Slade so that he could see my work, and he suggested a date at the end of March. I began to prepare my portfolio.

I don't have a distinct memory of my arrival in London that day at the end of March 1976. My sister Lucy had driven me to Taunton station with my portfolio, and my father had instructed me on how to get the Tube from Paddington to Euston Square station. I must have been very nervous, but I felt strangely confident.

When I went into the entrance hall of The Slade, there was a nice old porter in uniform waiting for me. He knew all about me and showed me into Lawrence Gowing's study: a small room leading off a large office space, where several secretaries were busy typing. The office was oppressively dark, despite the enormous height of the ceiling and the huge windows. I saw that the windows backed onto another even taller building, which must be

blocking out all the natural light. The room was lit by dim electric lights attached to long wires hanging down from the ceiling.

'My dear girl! You've come all this way just to see me!'

I was startled. A strange, tall man had burst out of the study and I knew this must be Lawrence Gowing.

I went into his study and showed him my portfolio. He looked seriously at my paintings, murmuring and humming as he did so. He burst out with 'Golly gosh!' when he came to a still-life with a stuffed sparrowhawk. He asked me if I would let him keep the portfolio with him. He said there was no question that I should start at The Slade that autumn. He said that he would write to my father. Lawrence wrote a wonderful letter to my reluctant father, which persuaded him to let me go. 'Pictures unpainted make the heart sick,' he wrote.

When I went back to school for the start of the summer term, I knew that I wouldn't be there for much longer and the thought was exhilarating. I didn't tell Linda my news. Miss Bailey was triumphant. She said I was the 'light of her life'.

On the last day of term, after all the exams were over, I knew that I needed to tell Linda the news. We walked together in the garden at Belvoir that evening. The great heatwave of the summer was just beginning and the air was sultry. All the huge irises were in bloom. The tension between us had eased in recent weeks and we realised how special our connection was.

Linda said that she had something to tell me: she was going to leave the school and go to a sixth-form college in Bath. She had told her parents she was unhappy and that her friendship with me had become unbearably oppressive. Her parents could see how stressed she was. They had been very

concerned and had made enquiries. They felt that the remoteness of the school's setting was intensifying the claustrophobia Linda felt and that she would be happier in a school situated in a city. She was pleased by the decision and was looking forward to the change. She told me she loved me and that it broke her heart to say goodbye.

I was now freed by her confession to make my own. Linda congratulated me and seemed genuinely pleased for me and excited by my news. We held each other in our arms and kissed each other goodnight.

That August the heat in London was intense. All the buildings and pavements were saturated with warmth. My father, mother, Kate and I all stayed in Ladbroke Grove so that I could get some sense of my new environment. At the end of August the heatwave broke and there were torrential rainstorms across the whole of the south of England.

By the time I started at The Slade on 30 September 1976, London looked very different.

The House Where I Was Born

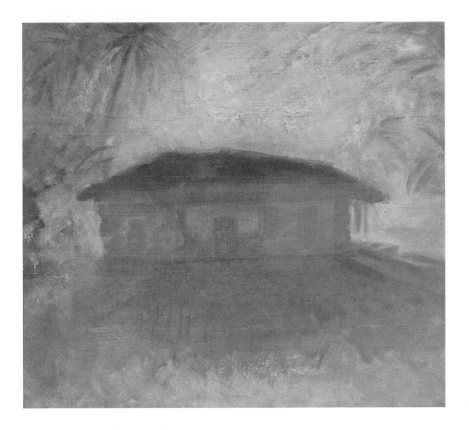

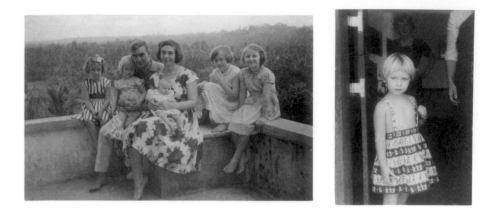

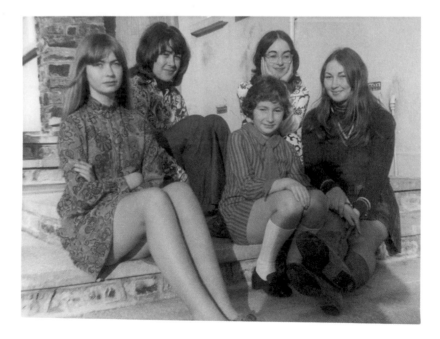

For my nineteenth birthday Lucian bought me a pair of Java finches from a pet shop in Parkway. The birds kept me company in my basement room in the chaplaincy. As the days grew shorter towards Christmas time, no daylight penetrated the room. I felt how homesick the birds must be, and I was unsettled by the rattling of the bars as they fluttered in their cage. I felt imprisoned, too. Lucian hadn't given me his phone number, so I often spent days in my room, too afraid to go out in case I missed his call.

Four days after my birthday I was feeling particularly apprehensive. It was evening and I put on my long green corduroy dress, over which I wore a small silk 'jacket', which was actually one of my mother's Indian tops that she had worn under her saris when we were in India, where I was born. My parents had been missionaries there. My father was the head of a theological seminary, and we lived in a little whitewashed, red-roofed house in the compound of the seminary in Kannammoola, a leafy suburb of Trivandrum (now Thiruvananthapuram), the capital of Kerala.

I had left India when I was five, but I remembered it, especially the house and garden: the intense heat and the beauty of the flowers, and the feeling of danger everywhere – snakes and biting insects, and the sense of there being no boundaries.

Our front door was always open, so that beggars and madmen often came into the house. It was especially frightening at night. The drumbeats from the Hindu festivals would echo up to our house across the paddy fields from the Hindu temple in Trivandrum. The drums would be accompanied by chanting and screaming, which would reach a crescendo and then suddenly there would be silence, punctuated only by the lonely howl of the jackals.

My mother had been radiant in her richly embroidered dresses and saris. I loved her passionately. When my younger sister Kate was born, I was so traumatised by being displaced in my mother's affections that I resolved to die.

I refused to eat. I became really ill and was diagnosed with leukaemia. I was first of all treated in a hospital in India, but when I showed no signs of responding to the treatment, my father decided that the whole family should return to England so that I could be treated at Hammersmith hospital. My three older sisters had all been sent to boarding school in Ooty, in the hills. But now we would all be educated, for a few years at least, at day schools, first in Southsea (where we stayed in a gloomy house owned by an elderly spinster who rented her house out to missionaries on leave) and then in Bristol, where my father was made canon of Bristol Cathedral. And then we went to Lee Abbey, where we all had to go to boarding school again.

After my treatment at Hammersmith I was pronounced cured. My parents said it was a miracle brought about by so much prayer. I thought otherwise. I knew I had brought the illness on myself in order to get my mother's attention. I succeeded. My mother gave me her devotion for the rest of her life.

*

When I was five years old I said to myself that I must remember my dream – whatever it was – because it was my last night in India and, for that reason, it would have significance. I dreamt that a little Indian girl climbed through the window into my bedroom and stole all my story books and children's magazines that I kept on a table by my bed. She was a savvy, lively child who knew exactly what she was looking for. She came out of the wide Indian night and aimed straight for my narrow window: the shutters were thrown back because of the heat. Through the mosquito net that formed a tent over my bed I saw her bright, avid face at the window and her wiry arms and legs as she climbed through. She was wearing a brightly coloured skirt and her arms were tightly ringed with bangles. In my dream I heard the quick rustle of her hands on paper as she snatched up the books, and I heard the silence of the room after she had escaped back through the window out into the night.

I was to return to the little house in Kannammoola forty years after leaving, when I was forty-five. My father had been dead for twenty-two years. I came back specifically to make studies of the outside of the house and garden, so that I could do a painting from the studies when I returned to

my studio in central London. I had planned to stay in Trivandrum for three weeks, but homesickness overwhelmed me and I managed to rearrange my ticket so that I ended up coming back home to London after only four days. I arranged my return flight on the third day, before I had even seen the house in Kannammoola.

I was staying in a hotel in Trivandrum and had intended to go, straight after my arrival, to visit the new occupant of the little whitewashed house that we had lived in: an Indian clergyman who was now principal of the theological seminary. There were no white people there now. The clergyman seemed reluctant for me to visit and soon refused to answer my calls. I thought the whole trip was proving to be a failure. On the third day, however, just after I had booked my flight back to London, I managed to speak to the clergyman's wife, who, after a murmured consultation with her husband, invited me to the house at 6 a.m. the following morning. I would be returning to London in the evening, so it would be my last chance.

That night I didn't sleep. The heat in my room was intense, despite the attempt at air-conditioning: a big, rattling fan attached to the ceiling. I lay on my bed all night watching the rotating movement of the fan. At five-thirty I went down to the hotel lobby, and the young waiter from the night before came out with me into the still-dark street to help me hail a rickshaw to Kannammoola.

Even at that hour, the streets of Trivandrum were packed with traffic, and the sound of the horns from the rickshaws hooting incessantly was deafening and made me feel even more nervous than I already was. We passed the Hindu temple and headed out of the centre of town. Soon the

streets thinned and became quieter and dustier. We came to some gates at the edge of a wooded area. The rickshaw driver informed me that this was the entrance to the Kannammoola theological seminary.

The sun had not yet risen. I made my way up the sloping path in the half-light through the trees until I came to the top of the hill. I looked down to the right. In a little dip, sheltering under great tall palm trees, was a small whitewashed house with a red-tiled roof. At that moment the sun came out and threw the shadows of the trees onto the whitewashed side of the house. The birds began to call. I sensed the spirits of the five little girls – my sisters and me playing in the garden, watched over by our mother – and I sensed the presence of my father standing there, looking out over the paddy fields and beyond.

Lucian

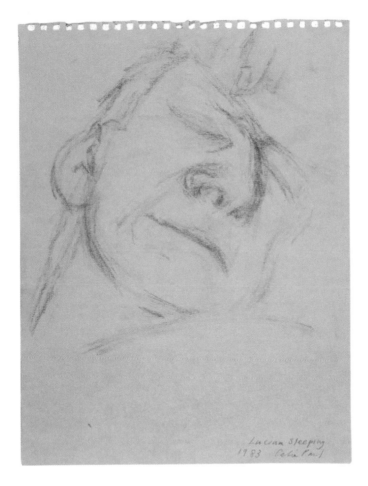

Lucian Sleeping
1983 Celia Paul

His sleeping profile like wax
And the closed eyes sealed down
Blind wax frighteningly still
Don't don't don't
Open your eyes
And catch me looking
I am senseless as the cushion at your head
Remember
I have no eyes.

The top I put on that evening was like a silken bolero, smoke-blue and bordered with silver leaves and small flowers. I was preparing to go out to dinner with Lucian and Frank Auerbach. Frank would, in future years, give me encouragement and support for my work; Lucian and I named our son after him. Frank's wife, Julia, became a support and friend to me, too. But at the time of my first meeting with them both, I was intimidated.

I recorded the evening in a notebook that I occasionally used as a random diary to jot down my thoughts and feelings. I sometimes wrote poetry in it, too.

*

15 November 1978

Lucian asked me the night before if I wanted to go out with him and Frank Auerbach; I was nervous, excited too. I asked 'Is he daunting?' Lucian replied vaguely 'I don't know. I've known him such a long time.'

I go round to Lucian's between 8.30 p.m. and 8.45 p.m. He has one of those doorbells with a little speaker beside it, so that when you ring and he is expecting you, he coos out 'Yes' in a mellifluous voice, and the door miraculously unlocks itself with a buzzing sound. If he's not expecting you he bellows 'Who is it?' again and again, never hearing my timorous 'Celia' until eventually I return his bellow with my own, whereupon he grunts and the door flies open. You have to climb God knows how many stairs until you arrive panting at the top floor where there is a bicycle leaning against the wall. Just before you mount the last little flight of stairs to Lucian's flat, there is the jangling of many keys, the door opens and Lucian leans against

the bannisters and looks down upon you, smilingly, tilting his head as you mount the stairs with pounding heart. Lucian's gestures and positions are always most aesthetically and sensitively contorted, like the delicate convolutions of a climbing plant, all sensitive tendrils. And the delicate head-jerks and twists of a wild bird. He receives you nervously, tentatively at first and then he lunges at you, kissing you as if he would drown you, then as suddenly withdraws and with serious abstracted expression moves towards the hall. This night he says he is just about to have a bath when I arrive, so would I mind waiting.

I sit down on the floor in the hall, beside one of Rodin's great Balzac statues (proud and pot-bellied) and listen to the gentle lapping of bath water, my heart hammering in trepidation at the thought of the encounter with Auerbach. Lucian wanders into the hall from bathroom to bedroom and back again, with a purple towel tied round his waist, casting me a smile to stir my roots, with such an endearing, nervous head contortion. I continue to sit for a while, trying to convince myself that the silence is peaceful rather than embarrassing. He joins me, now fully clothed, and we're off, to collect Auerbach.

As Lucian drives, he rests one hand on my knee: this fills me with such warm pleasure. All the traffic lights are green for us. We arrive at Auerbach's studio. Lucian gets out of the car and goes through the gate and follows the sign 'To the Studios' down a flight of steps. He enters the studio and closes the door behind him. The house, from which the studio is rented, is Victorian and somehow castle-like (perhaps the full moon lent an atmosphere). It is wedged between more Victorian houses and some very square modern ones, all glass and concrete. I wait nervously in the car, wondering if I should

get out and relinquish my seat in the front to Auerbach when he comes. Eventually they appear: Auerbach, a woman, and Lucian.

I cannot easily see what Auerbach looks like, lit as he is by only a dim streetlight, but I see him smiling towards me. He and the woman travel in a separate car from me and Lucian. The woman drives. Sometimes their car draws level with ours and I glimpse Auerbach sitting unsmiling, brooding, yet at the same time almost saintly in the depths of his seriousness, with a scarf tied around his neck. I imagine his hands clasped in his lap. We drive to Wheeler's fish restaurant in Soho. Lucian and I arrive first by a few minutes. I follow him to a cloakroom where a jovial man, obviously well acquainted with Lucian, takes our coats.

We are joined in the cocktail bar by Auerbach and the woman. No introductions, or perhaps Lucian says 'This is Celia Paul' and Auerbach is looking the other way. Auerbach orders a dry sherry, the woman a gin and tonic. Lucian has a Pernod and I (though I'm still ashamed at the thought of it) order a Cinzano. We sit down at a table where there are some olives, peanuts and a few biscuits. Lucian immediately pounces on the olives and peanuts and starts devouring them, desperately, nervously.

I study Auerbach. He has a huge forehead, and a sort of deep silence about him which is never broken, even when he is almost continually talking, in a slow, precise way. His head is slightly lowered and he gives quick darting glances at you as he speaks, never meeting your eyes. He has a warmth about him yet he always remains very reserved. He never flatters, he has no social graces. He does not make you feel welcome. In his presence Lucian becomes mischievous, outrageous, outspoken. He glances at me almost all the time which makes me feel very uneasy. The woman doesn't say a word and nor do I.

We do not say a word to each other, either. Two dynamic scintillating men and two silent bewildered and embarrassed women sitting eating olives. It is thought mundane if you do not talk about art or literature or a well-known person. I discuss the menu. They talk about a painter friend of Auerbach's who used to paint quaint green landscapes and who has now just had an exhibition of cartoon-type sculpture things: somehow a toothbrush, an old razor blade and some nails had been combined to produce a perfect likeness of William Coldstream or Euan Uglow or someone. Everyone agrees that the exhibition had been refreshingly and surprisingly good. It sounds very corny to me. Auerbach refers to his old pupil as being very benign. He uses the word 'benign' a lot to describe a person.

I feel that my silence is becoming rather an embarrassment to Lucian so I try to harness my voice which seems to have escaped me for too long. I ask Auerbach if he has seen the exhibition of Neo-Realist paintings at the Hayward (I know he has because my friend Jean saw him there the day before).

He replies that he had and he tells me what he thinks of it. 'Very entertaining. It really was extremely lively. Those artists described a specific time in Germany in a way that no British artist has ever been able to do in British history with the one exception of Hogarth in eighteenth-century London. The gallery was packed with German women, all in suede boots and tight trousers, dashing about all over the place.'

He finishes telling me his opinion in such a finite way that I feel unable to proffer my own opinion which is the main reason why I had asked him in the first place. Lucian realises my intention, and asks me what I'd thought of it. I reply that I certainly think it is lively and entertaining but that I didn't like

the thin way the paint had been applied and that I thought the paintings were mostly illustrative. Auerbach says that was the whole point of it! I am crushed. Then they revert to their discussion of the toothbrush and nails sculpture.

Lucian suggests that it would be interesting to sculpt a man with a carved chip on his shoulder. At this point the waiter arrives with the menu. We all order oysters and then I have prawns and lobster 'Walleska' in a brandy and cream sauce (I am very sick afterwards); Lucian has mussels in a sort of gruelly-looking thin soup which he fishes out with a spoon; Auerbach has turbot and the woman has sole. They start to talk about some woman who had invited Auerbach to come to a house-party she was holding in her country mansion. Apparently she keeps two pet lions which lope casually through the rooms. Auerbach declined the invitation. Lucian had apparently stayed with her once and he describes the creatures as being quite harmless, smelling aromatic as honey most of the time, but at regular intervals (every quarter of an hour) they would exude this absolutely incredible overpowering smell of rotting meat which you had to politely ignore.

Lucian is on top form. His excitement seems to lift him an inch from his chair. They then remember the days when Matthew Smith used to join them at dinner. After every meal he would apparently let out a satisfied sigh and then, rubbing his hands, he would say 'Right! Now, where are the ladies? To bed!' Both Lucian and Auerbach think highly of Matthew Smith's work. Apparently he would paint very fast, producing one or two paintings in a day. I am very silent. Lucian touches me gently on my spine. I feel my bones melting in gladness. Auerbach is working on a painting which includes some figures on steps. He tells us how important it is to count out the steps and get the right number.

Lucian's daughter Bella arrives unexpectedly, wearing a black coat. Thin and translucently pale (her skin seems to have a halo about it), she has very black hair and dark eyes. She looks like an El Greco saint. She stands before Lucian so innocently. She looks so vulnerable. He promises her some treat and tells her not to forget. She replies, digging her hands deep into her pockets, 'I wouldn't miss that for the world.' Lucian is very gentle and kind to her. She sits on a high stool by the bar for a while lost in thought and suddenly tragic. I look at her out of the corner of my eye but Lucian keeps looking at me to read my expression. He still has his hand on the nape of my spine. I do not look at her again. She then says she has to go. 'Enjoy your dinner!' she says. That nearly breaks my heart, I don't know why. She didn't take any notice of me, nor was she at all suspicious of me, or hurt at all by my presence. She must be about my own age. I sense a feeling of unrest and embarrassment coming from Auerbach at her arrival. Auerbach keeps glancing anxiously at me, and so does the woman.

The conversation turns to a lecture Rodrigo Moynihan gave at The Slade which Auerbach and Lucian had been to. At the questions afterwards, Moynihan had been asked what he thought was the most underrated and the most overrated painting, in his opinion. He had said that 'Homage to Delacroix' by Fantin-Latour was the most underrated and that a circus scene by Signac was the most overrated. I sense that Lucian and Auerbach don't agree. Auerbach says that in an examination when asked the same question about authors, his son had said that Samuel Beckett was the most overrated and Nabokov the most underrated. Murmurs of agreement and approval. We have now reached the coffee stage. We all ask for black coffee apart from Lucian who at the last minute changes his mind and calls after the waiter for just a

little milk please. The waiter didn't hear, however. Everyone else pretends not to have heard too. During coffee, Lucian tells us about the gala performance of *L'Africaine* that he had seen which he says was 'absolutely incredible.' Especially the storm scene in which a vast ship was dismantled among very realistic-looking waves. The scenery had been designed by a young Italian girl.

It is time to go. While Lucian goes to fetch the coats, I tell Auerbach about Madame de Bara, the fat French cabaret dancer who I have just finished painting. He mentions another model who lives near him and who has very long hair. 'It couldn't be the same one, could it?' he says. I say I don't think so. Silence until Lucian and a waiter return with the coats. The waiter helps me to put my ragged coat on; after much difficulty with the ragged lining of the sleeve, I manage it. Lucian and I say goodbye to Auerbach and the woman and we set off Holland Park-wise, Lucian asks me what I'd like to do next. I say that I'd like to go for a walk.

We get out of the car at Hyde Park and walk down a tarmac path past the Serpentine restaurants. We walk through dead autumn leaves. I comment on how nice it feels to walk through the leaves and Lucian says 'Yes, the ones like breakfast cereal are the best.' We kiss, of course, and then go back to the car.

He asks me whether I should like to stay the night.

'Do you really want me to stay the night?' I ask.

'I would love you to,' he replies.

*

When the Christmas holidays came, I packed up my few possessions and paintings. I was leaving the chaplaincy. After the holidays I would be renting

a room in Ladbroke Grove. The house was owned by an aristocratic Russian lady who let out rooms, mainly to foreign students. The room that I had reserved, and which I would move into in January, looked out onto the same communal gardens that I had looked out onto when I first came to London. Lawrence Gowing had insisted that I live with a family for my first year at The Slade, on account of being so young. My father had arranged for me to live with a clergyman friend of his and his family in St Basil's House in Ladbroke Grove. It was next door to the house that I was about to move into. St Basil's House had a chapel on the ground floor, and a Russian Orthodox priest, Father Lev, lived in the basement. Father Lev would call me his 'dear alligateur' because we would often be passing each other on the stairs, and he would greet me with 'See you lateur, my dear alligateur.' He had a heavy accent – French, I think, rather than Russian. Lucian later labelled him 'the naked archimandrite' because, one evening when I was walking with Lucian in the garden square, we saw Father Lev naked in his uncurtained basement room. With his long white beard and sacred air, he appeared like a sort of St Jerome in his study. He was very thin, so that his buttocks were almost concave. Lucian said that his bottom must have been shot off in the war.

My mother was shocked by my appearance when she saw me. My hair was matted and I looked white and unwashed and ill. She cried. She was frightened for me by this love affair with a much older man. I couldn't justify myself to her, because I too felt that my growing love for Lucian was more like a sickness. I resolved to try and forget about him and to re-establish my ambition. I determined to do a painting of my mother. I asked her to take off her clothes and she lay down on the mattress for me, in the room that had been assigned to me by my father as bedroom/studio. The window

looked out onto a great lawn that stretched all the way to the Humber river. They were building the Humber Bridge, so the river was landmarked by a towering crane. The Humber bell tolled mournfully on foggy days and during the night. There was an enormous beech tree to the right of my window. I peremptorily instructed my mother about what position she should assume: she should lie on her back and raise one leg slightly. When she faltered and didn't get the position just as I had wanted, I shouted at her. I was very cruel. She cried and said that I was treating her like an object. I responded irritably to her tears and said that she didn't believe in me. She complied and continued to pose for me, day after day during the holidays.

I was constantly on edge, waiting for a call from Lucian. He had said that he would write to me. I would rush down to the front door each morning when the post was due. I would counsel myself on my way down the stairs not to be too disappointed if no letter from him had arrived, and each morning after I had sifted through the letters and discovered that today's post consisted of official-looking letters addressed to the Bishop of Hull, my despair would be so great that I couldn't work or do anything. One morning, however, the longed-for letter arrived. Lucian enclosed forty pounds. He wrote a description of his love of driving on ice (there had been a thick snow in London, which had turned to ice) and said that he missed me and wanted me to come back soon, to be a 'head for his bed'. I was elated.

At Christmas my three older sisters – Rosalind (always called 'Mandy' by her family because her middle name is Miranda), Lucy and Jane – joined Kate, my mother, my father and me. My working routine was disrupted.

*

I wrote in my notebook:

I am surrounded by memories of Lucian. To my right the Java finches in their cage. They have been with me for over a month now, observing my moods which change with the tide of his affections. And to the left the canvas which he gave to me as he said goodbye and kissed my hand.

I cannot sleep until very late and as a result I wake up late. Then it is lunchtime and I have some wine and then it grows dark and my day is gone. I feel hopeless. My excuse is that there are so many people here and they undermine any confidence I might have. Dad says, on giving Lucy her drink: 'I'm sorry to serve you last since you are the creative person in the family. Kate is served first because she is the genius.' Then Mandy says: 'If we'd all had as much attention as Kate we'd all be geniuses like her.' Mother looks at my father warily perceiving my jealousy. I slip out of the room knowing I am neither creative nor a genius, that I haven't even attempted to do any work for nine days and have done no good work for two months. Please let this time be like a black passing cloud. I know I have always had these dark obliterating clouds – if only I knew how to dispel them quickly. Please please please may I start working brilliantly soon. I am so nervous about taking my picture back to London. Say Lucian hardly notices it?

I feel so sad at the moment. I know now that I will never finish my painting of Mum. I cannot feel it is worth spending the time on it. I have just wiped away the painting I have done in the past three days from the canvas because the paint was too dark and grimy, too slack and half-hearted. I really must be able to spend at least three months on a painting soon or else I will be suffocated by the increasing debris of unfinished paintings. I have hardly achieved anything this holiday that I can prove. The hours have moved fast,

though (at least during daylight), and I have stuck to a schedule, working every single day except for the days around Christmas. And I have hardly anything to show for it. I feel my energy falling from me. I can hardly believe that this agitated enervation can persist so determinedly.

I soon go back to London, to my new room in Ladbroke Grove – to obsessions and loneliness. It is going to be hard for me. I have never really had to live absolutely on my own before. Evenings are intolerable. Depression sinks through me like a stone when the light begins to fail. Imagine what it will be like on my own in a house full of strangers. I will hear their loud music through the floorboards which will make me feel even more lonely.

*

A finger is unbinding the strands
That knit me to all I have loved:
Sisters in childhood kept
As shadows in the playground running
As I once ran, so close to me
Their breath misted the air above me.

Their footsteps echo now in my memory.

*

I climbed the stairs, holding the square birdcage in both hands. I felt the frightened fluttering of the finches, and the bars rattling against my fingers

as the birds panicked. My distinguished Russian landlady said, 'You didn't mention that you were bringing an aviary with you.' Her son followed behind us. He said to me, 'If Dostoevsky isn't your favourite novelist and *Crime and Punishment* isn't your favourite novel, I will absolutely never speak to you again.' He and Lucian were to have many a contretemps. Lucian would ring the doorbell, looking white and haunted (and Dostoevskian), and when Nikolas opened the door, Lucian would rush past him and up to my room on the first floor without saying a word. Nikolas would scream after him, demanding Lucian explain himself or get out. Usually I heard the commotion and could quickly spirit Lucian into my room and lock the door behind him. Once, when I was out when Lucian called, I found a note on my bed in Lucian's handwriting, saying, 'That snivelling little man tried to bother me.' Nikolas later complained to me that my strange and disreputable visitor had kicked him.

My room was big and bay-windowed. It was January and the branches of the plane tree were leafless. I was lonely and anxious. All my thoughts were for Lucian. The other students at The Slade had often told me that Lucian was notorious for having a lot of girlfriends at the same time and that he was never faithful to anyone. He was very secretive. I wrote occasional notes in my notebook:

*

54 Ladbroke Grove, W11

I have moved into my new room, though it doesn't seem like my own room. There must follow a period of courtship in which I woo the ugliness of carmine curtains and flowery sheets to be my own.

My loved one is so near I can almost hear him breathing. Yet I am terrified of approaching him. Every ring on the doorbell sends me to my mirror. Waiting all the time for the sound of the doorbell. The terror of waiting mounts from place to place as I become more and more accessible – not the telephone now but the doorbell.

The Spanish cleaning lady bursts in with her Hoover and polish. She stays with me for about half an hour telling me about her infamous next-door neighbour who cooks for a home for the blind preparing food that smells horrible. Because the blind people can't see, the neighbour delights in presenting them with food that looks like vomit.

After the cleaning lady leaves, the girl in the room next to mine starts playing Spanish music: a man with a voice like a plucked rubber band, and so loud. I give up my painting and take the bus back into central London. In fact the best bit of the day is eating a perfect croissant from a French patisserie near The Slade. I meet beautiful Gail, the model, and I arrange to draw her next Wednesday.

I buy some cakes for Lucian and take them round to him this morning. He is very pleased to see me. Then he shows me how his painting has developed since last I saw it. There is a great yellow aspidistra leaf sprouting in the middle of such intricate delicate foliage. I am taken aback at first by its vividness and I show my surprise too much. He is terribly hurt and anxious about it for the rest of the time and I slip away without him really saying goodbye. I feel very bad. Then he comes to see my room just after 4 p.m. today. He likes the room very much.

A couple of days later and I have Branston pickle for my supper. I'm so hungry. I haven't even got enough money for my Tube fare.

My skull is battered by the continual noise of the music coming from the next room. I think with envy of Lucian in his soundproof studio working throughout the night while I sit with earplugs in my ears and my pillow over my head, trying to block out the din so that one poor struggling thought might swim through.

I shall try hard from now on to build up solid bricks of tolerance and patience so that eventually I might be able to paint even in the most adverse circumstances. So that I will be able to paint even through blaring music.

My next painting is going to be very inventive. There is a creativity working in me like worms in sand. A cool still-life in the foreground; a chaotic activity in the background.

I am not lazy. I am desperate to paint.

Lucian barks like a rabid dog in the middle of Holland Park Avenue at a mad Sikh traffic warden with a banana-yellow turban who balances on one leg while checking the parking meters. Lucian also tells me of a Parisien who would stand in the middle of a main road in Paris and light a match or two by striking them on the sides of the cars as they drove past at top speed.

When I say goodbye to him a tall man is waiting patiently for his thin mongrel to finish relieving itself on the trunk of a plane tree. The mist coils off the urine and swirls round our feet: two men, one dog and one girl group portrait.

As I turn to walk away, Lucian gives me back the pair of gloves that I must have left last time, saying, 'Here, I found an odd pair of gloves somewhere which you can have.'

I must distance myself.

I think I will have to go home where painting stands ten thousand feet above the sea-level of my personal life. Here, my painting is a blurred underwater affair.

I am going to give up this room.

I babysit for the Gowings while Rodrigo Moynihan takes Professor and Mrs Gowing out to Wheelers (O memories sifting in). Rodrigo is invited in to whiskey beforehand. Professor Gowing begins to talk about Lucian, looking at me knowingly, so knowingly. Then he says this – and my life falls apart. I have to remain poker-faced in front of them both. What shall I do when next year begins at The Slade? Lawrence tells me about the beautiful and exceptionally talented girl who he describes as Lucian's 'light o' love' and who Lucian has introduced to Lawrence. She will be attending The Slade next year.

And all these months I have been thinking that, even if I wasn't the only one in his life, at least I was unique to him. How can I face her? She is apparently very beautiful and very detached and very tall.

I borrow from the Natural History Museum a stuffed 'Collared Plain Wanderer' – how apt – to paint. I work hard today on my painting. My paint brush acts as an amulet to ward off evil spirits and overpowering depressions. I don't care so much what the outcome of the painting is so long as I finish it. This is important. My self-respect mustn't sink down, whatever else does.

I go round to Lucian's today to show him my collared plain wanderer. I go round with the express purpose of charming him absolutely. I think I half manage it. His work is not going well which means that his mountainous arrogance is half replaced with a sort of humility and tenderness. From now on I shall be aloof.

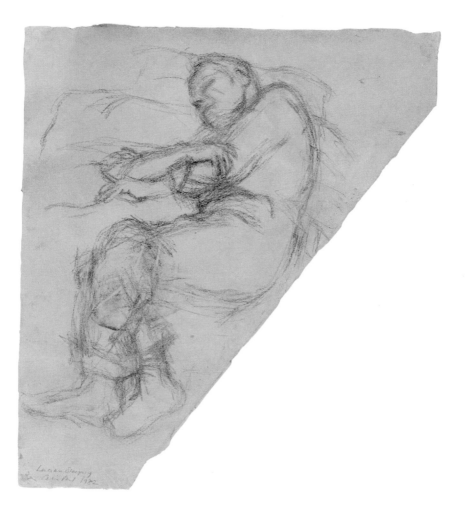

Lucian Sleeping
13th May 1942

*

Like prising up a stone
Is your gentle back now lifted from the sheets
To me,
And your shoulders that have lain quiet
As moss under a stone
Now are turned towards me
And your gaze is wandering
And it is you star-distant that I love

Always when you turn to go
There is grace in your turning
So that I would call you back
But I know
That it is the coldness of your going I crave
And not your returning.

*

The lake in the frozen grass is white white
As the sky
And the sailing boat masts that turn to cloud
Evaporating
Are ice-bright and hurt as much
As the white-hot gulls

Like sparks from flint that fly
And hook the eye
With stabbing points of bridal light
And who shall be most white?

And who shall be most white in a sky
That has been inverted like an eye
With beautiful iris a blue stain
Gazing at the brain?

*

Snowflakes like ghosts of summer midges
Blown down suddenly from a sky
That has lain close as a dress
The midge husks scatter
Into white silence
Stealthily, your slow shadow begins
To stain the snow
Soundless as the last leaf falling

*

I go to the Victoria and Albert Museum. A tiny Delacroix painting shines like a jewel in my otherwise dark day. The colours are so lustrous and you

discover here and there, for no reason whatsoever, tiny points of luminous turquoise paint that seem to grow from the canvas as unpredictably as bluebells in a wood. There is the hard glitter of metal and water in sunlight in his palette and you can almost imagine that, when his brush met the canvas, you can hear the clear ring of tapped crystal glass.

The other painting I love is the huge Constable sketch for the landscape with a horse leaping over a stile. The paint is so recognisably paint that it seems a mere accident that there appears to be a horse jumping over a stile and a few trees. It is like finding faces in clouds or peeling plaster.

I wake up at eight on Thursday morning and lo and behold! My love! We sleep around a bit (he likes my bird painting) and then go out to a breakfast of bacon and eggs in Queensway. Then we go for a walk in Holland Park (squirrels tamer than they should be; dancing cranes; leafless trees) and then sleeping around a bit.

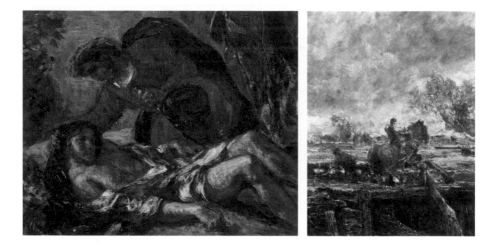

I saw Lucian's 'light o' love' in The Slade today. Apparently their affair is now over. Though he must have still been with her when he first met me. This is a very painful thought. She is having tea in the refectory and I found myself sitting opposite her. She looks so strange close to – a thin, terribly pale face, with lips that are bright red, the central peaks of which almost reach her nostrils. She holds this cold, almost blank, detached, enigmatic, unresponsive expression on her face like a mask. She is very haunting because she seems so free of natural emotions. It surprises me when she says that she likes it at The Slade and is looking forward to it very much. I can't imagine her harbouring any sort of anticipation. She looks very ill. As she sits with her cup of tea she has a spasm of pain. She is deathly white and thin. I will be friends with her.

A strange morning leaving me feeling disoriented. It is quite alarming to suddenly change the image someone has had of you by revealing a hidden area of yourself. I speak to Lawrence Gowing about Lucian (which I have never done before) and hey presto! Out splash the tears! Lawrence says that now he is even more fond of me than before for loving and admiring Lucian – and what good taste! He says that he has known Lucian since he was sixteen and knows that he just doesn't commit himself to one single person – not through unconcern but just because this was the stony cold mode of living that his art flourished on. Perhaps the sickness that I feel in the pit of my stomach, after confessing my feelings about Lucian to Lawrence, is not through shame of revealing something hidden but of suddenly being truthful and of being met with a truthful response. He tells me that his whole family has just been converted through his children's delight in religion. He asks me to go to

church with him and his family but I say I did not believe – that is another shock for him. I then ask if I can paint his portrait and he says he would do anything in the world to help me. He has arranged for me to have a tutorial with William Coldstream as he says this is an experience I should not miss. Bill's philosophy is that you should just paint what's in front of you. Before you is an image which you should grasp with both hands, forgetting about harmony and balance which should spring naturally enough from yourself anyway. When I say that I am going to be terrified about starting the portrait of him, he says that I am the least terrified person he has ever met in his life.

<div align="center">*</div>

Chardin exhibition in Paris. Shall I go?

On Friday night at ten-thirty Lucian rings and asks to come over. It is Lucian at his most gentle and most considerate. I take him round the garden square that my room looks out onto. The clock is striking midnight. We gaze at the stars but his expression is more stellate. He promises to return the next day.

In the morning I walk through Kensington Park Gardens in search of the V&A to pay homage to the Constable sketch of the Leaping Horse but I get lost and can't find it.

Lucian arrives with a huge bunch of yellow narcissi. I am trembling so much because of the unexpected gift that I can hardly lead the way up the stairs. Why did he bring me those narcissi? Their scent fills the room.

<div align="center">*</div>

In Paris by myself. My room is on the staircase so it feels as though I am tottering precariously on a waterfall of footsteps as people trample up and down the flights of stairs incessantly. My privacy is very much interfered with this way. There is only one blanket on my bed and it is freezing cold outside. The sky only managed to squeeze out a few flakes of icy snow: it is using up too much of its energy in icy winds and air which is composed of stratas of coldness.

My room is small with yellowing wallpaper decorated with vertical stripes made up of flowers: poppies, cornflowers, Michaelmas daisies, and a spray here and there of rye-grass. The red curtain is drawn across a window which looks out onto a wall about a yard away. Nothing else is visible except, if you crane your neck, a bit of sky.

My bedspread is nice – faded olive green with a stripe of mustard silk on either side. During the night I hear, from some untraceable source, in some room divided from mine by paper-thin walls, someone hammering screws into wood. It is about four in the morning. Who could be doing carpentry at that hour? And then I hear him playing with the screws, dropping them and then moving them around, as though he is playing some crazy game of jacks with them. The unlikeliness of this picture scares me a lot.

*

During the summer holidays that I spent in Hull with my mother, father and sister Kate, I did a big painting of my mother and Kate. My mother is lying down on a bed, and Kate is naked, sitting cradled by my mother with her thin back turned towards me. By my mother's head is a pile of books.

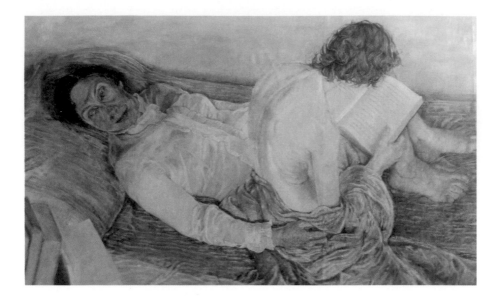

It was my most ambitious painting yet. When I took it into The Slade in the autumn term it created quite a stir. Lawrence hated it. He sarcastically mimicked me giving instructions to my mother: 'Just one more varicosity before tea, Mater.' He was right. The feeling is overly charged and strained and the composition artificial. Lucian liked it, however.

When I went back to London in the autumn I moved into a new room around the corner from the house in Ladbroke Grove, in Kensington Park Gardens. My tenancy was only for a month, so I would soon have to find somewhere else. It was a tiny room on the top floor. The other tenants again appeared to be foreign students. A friend from The Slade helped me to carry my big painting from The Slade to my room, into which it just fitted. It dominated the far wall opposite my little bed.

I wrote letters to Kate about my room, and about Lucian's response to my painting:

He has just been to see my painting and he thought it was absolutely beautiful. He really did. He said it was like a landscape or a seascape. He said how still it was, especially the books. He said it was very inspiring. I wish he had been elated about his own work. Because I suddenly became so smug, trying to cover up my smirks. But a smirk cover-up is more smirkish than a smirk and so he thought I was really smirking.

Thank you, Thank you, Thank you for posing for me. I hope his work goes well. He was a little sad about his work when I first went to see him and now he is really sad. And all because of my damned paintbrushes (which are mainly his damned paintbrushes). I love my room. I have never felt so at home in a room before so immediately. It is a little ship's cabin way above the trees. Please come and stay and we can sleep in my little matchbox bed. The room has a perfect colour scheme for the painting – pink, white, grey, blue.

Let me speak to you about things. So much has happened.

I had just finished cleaning my teeth and was coming into my bedroom when I saw my love waiting there at eight-thirty in the morning. He has not been well and was aching all over and I wished I could have made him feel better. I'm afraid I was very clumsy with nerves about the West Indian housekeeper and the creaky bed and its narrowness and the paperthinness of the walls and heat and tiredness. But he came to tell me that he was bringing Anthony d'Offay the famous art dealer to see my painting in the evening. I was so flattered. He said he would sound the car horn thrice to summon me to open the door, because the West Indian housekeeper, the official door-opener, is so inhospitable. Sure enough, at five-thirty, this

enormous foghorn-type boom [Lucian owned an enormous Bentley] echoed three times through the street, bringing everyone running to their windows. I had somehow imagined Anthony d'Offay to be short and squat and balding and complacent – but not at all. He is very distinguished-looking, very hard and aristocratic and fairly young. He is slim and tall wearing an immaculately tailored grey suit, narrow lidless eyes, fairly thick black eyebrows which almost meet in the middle and watermelony but sensitive lips. I was shaking from head to foot with running down six flights of stairs to open the door but was consoled in my heart with my image of the complacent Anthony d'Offay. When I saw him hard, uncompromising, discerning and admirable, my shaking doubled so that I was practically rattling. When he looked at my painting an eternity of silent embarrassment seemed to pass. I could tell that he really hated it, but there was no getting away from it in that tiny room. Lucian was attempting to find himself a seat on the windowsill and was staring fixedly out of the window. After some moments Anthony d'Offay asked who the people were, where had I painted it, did the models just pose for me in the morning, where was the light coming from, what was I working on at the moment (nothing) etc. I asked him if he'd like a Chinese fig as I had just bought four from the market. After some moments, under extreme pressure, he said, 'It's a remarkable painting.' Even though I knew he couldn't have said anything else under the circumstances, I felt very relieved.

Lucian then joined in the conversation and brightened it a good deal. (Oh, and I knocked all the books off the bookshelf.)

Then they went and Lucian said he would ring me in ten minutes and I could have howled my head off. Lucian rang and said that he would ring me again in the morning. So I have that to wait for. I love him so much.

I must resolve to work hard. If in my next letters I talk so much of other things send me a horsewhip so that I can lash myself into action.

<center>*</center>

Dearest Kate,

It's the weekend and I am bored.

I have just bought myself the first volume of Proust – *Swann's Way* – which is pleasing me. But I am so filled with restlessness and guilt at my endless leisure so that I am always on the brink of being melancholy that I can't read a page or two without casting an apologetic ... Oh, Kate, the telephone just rang and it was for me but when I lifted the receiver no-one answered or else we weren't properly connected. I feel so despondent and disappointed. The payphone is in the corridor and the boy who answered it said that it was a young man on the phone for me – Daniel? Chris? Andi? Brian? Alan? Ian? – Oh, Kate! ... and resentful glance at my easel with its arms thrown up in despair.

I have just been trying to paint a self-portrait (five hours later). It's the sort of face which, if it was peering out between the shoulders of two people in a crowd painting, one would notice and say 'that's rather a good face' but as it is, the sole subject of the painting, it crumples up with embarrassment at its own shabbiness. I tell you what's wrong with it: I'm not putting my whole heart into it so that the poor face is dying through lack of love.

I found a giant of a green marzipan man which some child had obviously created and nibbled at and discarded in the gutter. I can't tell you how I relished that delicious monster of a guttersnipe man!

I long for HIM all the time (not the green marzipan man, you know) but he does not phone too often. I spent Thursday night with him and I never wanted the night to be over.

Oh, he has been phoning me but I have always just missed him. He asked me on the telephone to come over and I said 'Now?' and he said 'Yes. In fact five minutes ago.'

I wore this absolutely putrid mustard-coloured coat which Jean [Matthee, a fellow Slade student] had bought me from Camden Market. Lucian talked to me about Peter Scott who he described as being 'sincerely, honestly and truly false.'

I am longing to take you to St Quentin's Brasserie (proprietor Quentin Crewe esq). This time I had a vegetable terrine – so delicious and very hard to describe – it looked a bit like Japanese origami – very beautiful. Then I had steak served with a peak of mashed potato coated thick with roast almonds and fried chicory. Then the dessert: the best thing I have ever tasted – a tart made with crisp butterish pastry topped with strawberries, Chinese gooseberries and cream. Lucian had soup, monkfish and apple tart – the poor fool. I am longing for you to taste their snail dish. The waiters all loved me and they put a daffodil on top of the potato and nut peak for me.

*

My tenancy was running out and I needed to find a new room.

In the hallway at The Slade, outside the offices, was a noticeboard. There was an advertisement written in rounded, careful handwriting for a young woman Slade student to occupy a large room in a house in Belsize Park for

very little rent. It was signed 'Mary Bone' and there was a telephone number, which I rang and arranged an appointment.

I wrote to Kate about my new room:

I'll tell you in detail about my new room and house. Big and Victorian house with chestnut trees in front and a front door like a concrete slab. Mrs Mary Bone, proprietress, opens the door. She is big and calm, wearing a pinafore dress and elderly and artistic (without being arty) and aristocratic. She takes me into her sitting room which is joined by a knocked down wall (not crumbling down, you realise, but punched through cleanly, surgically, like the holes punched by a hole-punching machine) to her studio where she has been working on some paintings of houses – the only notable thing about which is the lack of inspiration. By the way her head is like a coconut with her hair combed over her scalp in a continuous thin fringe until it reaches the bun at the top. Over the fireplace in the great sitting room (but everything is 'great' and on such a huge scale in the house that I shall omit this adjective in the future) is an 'enormous' Stanley Spencer painting (thank God I knew who it was by). Actually, I think it's the best painting I've seen of his and is certainly very mysterious and powerful. She talks continuously and kindly, leaving you plenty of time to think of other things before your next question is needed to prompt her into swaying motion of speech. She then showed me the garden which is beautiful – a tall contorted oriental-looking ash tree stands near the kitchen door and is the starting-post to the rest of the long garden which finishes, among bamboo and bracken and other plants alien to London, in a summerhouse or temple thing. You can see right through the door of the summerhouse from the kitchen door and try to work out if it is an optical illusion or whether the chequered floor doesn't really slope up at a

steep diagonal. Apparently another garden leads out of the side of this and is also in the possession of Mrs Mary Bone. And then she showed me my room.

It must be the best. It's 'enormous' and looks out onto the garden and summerhouse. It is square with a big square window and a big square bed and such an amount of empty uncharted floor to walk across, where canvases can be stretched and parties can be held. And I have a sink and oven and fridge. And there was a television but I have a suspicion there won't be when I arrive. She says she will never come into my room or disturb me (you can imagine how I thought about lovers at this point). The window entertains a north light – the best for painting. Oh I feel I will be able to work at last. I have been feeling so frustrated because I have had everything inside me urging me to paint and have been unable to because of the smallness of my room and my cramped self-conscious space at The Slade. It has been like the leaves not falling when they are brown and curled and it's late October and the days are getting colder but some hesitation on their part or else some universal deterrent makes them cling on overtime. Still I have ten days to go till I can come out of my shell. But perhaps I can begin planning things – I would like to work on a painting during the day, say four days a week, and go into The Slade to draw the other three, and then work every night on a painting. I wonder if Mrs Mary Bone could assist me by sitting. I doubt it. This should keep me from eyeing the telephone receiver too much like a hungry dog eyeing a bone (not Mrs Mary Bone, you realise).

I can't wait to start painting. I can't wait. Can't wait.

There will be so much room for you to come and stay with me.

*

My time in Haverstock Hill was the start of what was to be seven months of self-destructive drinking and promiscuity. The quiet presence of kind Mary Bone acted like a sort of superego against which I rebelled. When she was away I held drunken parties, where my guests made long-distance phone calls using her phone and broke her bannisters as they lurched up her stairs. We spilt wine on her expensive carpets and vomited on her bathroom floor. I was very cruel and didn't care if my behaviour hurt the people I loved. My brain was too blurred by alcohol most of the time to take any responsibility for my actions. I had many casual lovers. Lucian visited regularly, too.

I travelled to The Slade almost every day from the nearest Tube, Belsize Park. Very often I would meet one or two of the life models on my journey (they lived together in a big house not far from where I was staying): the models at this time were usually 'Orange People' who dressed in long orange robes and belonged to some sect that, I think, followed the 'Bhagwan'. They practised meditation when they sat for us in the life rooms. They sat very still for long stretches, but their stillness had an eerie, vacant atmosphere, which I found difficult to relate to.

Many of the students were very fashion-conscious. In 1980 punk was in its late incarnation and was becoming more pared-down, though aimed to be equally subversive. It was considered very desirable to have an androgynous figure. I was painfully self-conscious about my breasts and of my very un-androgynous body, and I often felt demoralised. The trend was to show no emotion. I didn't want to cultivate a cold, deadpan look. I didn't want to be fashionable, because I hated belonging to any group. But the influence to conform was powerful and I suffered when I felt that I was being over-emotional or earnest in my responses. You were supposed

to play everything down. People cultivated their facial expressions so that they appeared dour and unresponsive.

Everyone smoked more or less continuously. Great clouds of smoke filled the studios and life rooms from our cigarettes. When I had first come to The Slade, I was ignored by the 'cool' set, but since everyone now knew that I was going out with Lucian, I had gone up in their estimation. I made friends with several of them and we drank a lot of alcohol – vodka mainly – in my room in Haverstock Hill, which we knocked back from the bottle.

One of my closest friends from The Slade was a filmmaker, Jean Matthee. I often visited her in a house in Shepherd's Bush, where she was staying. On one occasion, when she was ill with flu, I wrote in my notebook:

She goes to sleep in her great bed. There is a bare twig fastened with string round one of the brass bed-knobs, bent as though by a strong wind. This gives the impression that the bed is flying at top speed across the room. She lies with her dark hair streaming out around her and her hard suffering face closed as a shell. When she wakes she reads a passage to me from Kenneth Clark's *The Nude*. She comes to a quotation by Francis Bacon which we presume is the contemporary artist. The quote is something like 'There is no beauty that exists that hath not something ugly in the making therein.' We both collapse with laughter when we imagine the painter Francis Bacon speaking these words.

Jean was intense and very gifted. When I first started at The Slade, I was in awe of the freedom with which she worked from the life model. She invariably worked in charcoal on very large sheets of paper. She easily and fluently captured the features and attitudes of the model, using just a few free marks. She captured the presence of the model too.

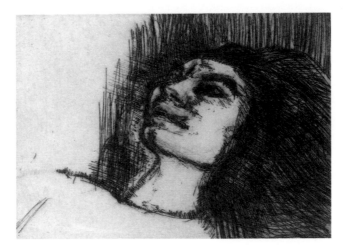

*

Some of the most interesting students were focused on Performance Art, under the tutorship of the influential Marxist performance artist Stuart Brisley.

One student spent a week in a cage that she had constructed out of wire netting in one of the ground-floor studios at The Slade. She had timed her performance to coincide with her period, wearing only a thin white nightdress, which gradually became more and more heavily spotted with blood. The cage floor was littered with blood-soaked sanitary towels.

Another student staged a performance in a darkened studio space in which he had erected a high platform. He hung a bare light bulb over it and positioned a table bearing what looked like a chopping board, a long piece of rag and a sharp-looking knife. He climbed onto the platform, and

his cheekbones looked cadaverous under the glare of the electric light. He then proceeded to tie the rag around his head and over his eyes, to form a blindfold. With one hand he felt around for the knife while he placed his other hand, with fingers splayed, onto the board. Then he attempted to cut round his fingers with the knife. Soon the area around his hand was running with blood from the gashes he was making on his fingers. I had to leave the room and I fainted in the corridor.

On another occasion the same student staged a performance that involved climbing to the top of the staircase inside the main entrance of The Slade and throwing himself down the stairs. He then picked himself up and repeated the action.

When a student friend needed to find accommodation, she arranged to stay in my room in Haverstock Hill while I was away in Hull for the holidays. This eventually became a permanent arrangement, and the friend proved herself to Mary Bone to be a quiet and conscientious tenant. My stay at Haverstock Hill was coming to an end.

Everyone at The Slade was gossiping about Lucian, and they delighted in telling me about all the people he was having affairs with. I became severely depressed. One night I swallowed a packet of Veganin, washed down by a bottle of whiskey. This landed me in hospital. I went home to recover.

I received a letter from Mary Bone:

> Dear Celia,
>
> In rather a belated reply to your letter, I'm sorry if the way your room changed hands was not as you had intended.

I had nothing to do with the transfer other than to hear from you that a friend might like to come there as you were at home for a long time and that she would get in touch with me – first I think you said she would like to store some of her belongings here – this she did then she said she had arranged to take over.

The room was left in such a mess, not only untidy, but really dirty, stained sheets and mattress. I don't remember you ever cleaning it. I was only too pleased to find that your friend wanted to clean it and to occupy it. I don't like having rooms left empty in that condition, and, in any case, would not have taken you on as a tenant next year.

Having said this, I have to add that in other ways you were a very nice girl to have around and I admire your painting, it is remarkable, especially considering your age, I am sure you will go far and succeed. But do try to be a little less Victorian bohemian!

What you want is a totally empty room, just one bed, table, chair, electric kettle and shower. This is what the housing group PATCHWORK provides in Islington.

They buy up derelict houses and just do the minimum repairs and provide one kitchen and one shower & WC

till they can afford to do them up properly. During this period they let to students at very low rents. When they are ready to do them up permanently they move you to another temporary situation, but they guarantee you a room somewhere. Why not try this? Now would be a good time to contact them before people settle in next term.

Yours,

Mary Bone

P.S. Please let me know when you are next in London so that I could take your painting things and pictures with you to The Slade.

*

That summer I did my first real painting: 'Family Group, 1980'.

I positioned my mother, Kate and my father. In the painting my mother is on the left, with her hand protectively on Kate's clasped hands. Kate is looking demurely down and my mother is looking directly at me. My father is sitting on the right; he is in profile and looks as if he is fighting off sleep. I had arranged their chairs against the window. I placed a narrow mirror on the wall opposite the window. The mirror reflected the beech tree in the garden. I painted the mirror as a narrow strip in the background, between Kate and my father. I painted myself reflected in the mirror in front of the dappled beech leaves: a thin, sinister silhouette.

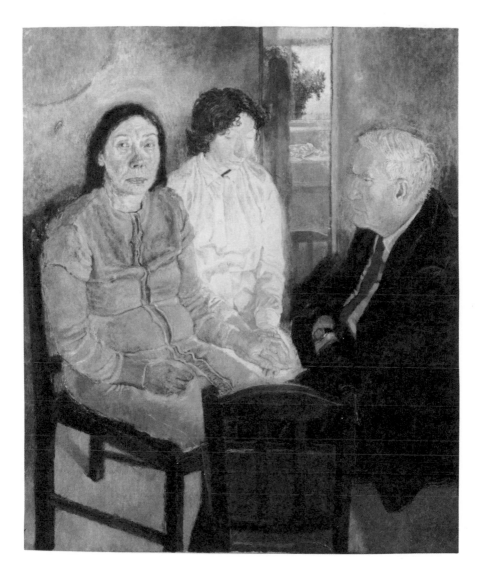

My mother's expression is fiercely protective of Kate and her expression is accusatory, though full of concern. The whole composition is lit with an inward glow.

When I took it back to The Slade for the autumn term, Lawrence said that it was a great painting, as good as a Gwen John, and the best painting ever done by a Slade student, even better than the painting by Michael Andrews, 'A Man Who Suddenly Fell Over' (now in The Tate), which was painted in 1952, when Michael Andrews was a student at The Slade.

Lucian admired it, too. In the weeks after seeing it, he often seemed preoccupied. He said, 'I'm thinking of your painting.' He started to think about doing a big painting involving several sitters, and he ordered his biggest canvas yet to be stretched. The blank canvas was to form a screen dividing his studio in half for nearly a year. On this canvas he was to conjure up 'Interior W11: After Watteau.'

During the time I was working on 'Family Group' I would travel regularly to London to see Lucian. I always took a bouquet of roses that I had picked from our rose garden in Hull. Lucian often didn't want me to arrive until one or two in the morning, when he finished working on his night paintings. I would usually go to a late-night film to pass the time (the roses would be wilting by the time I saw Lucian, but heavily scented and very beautiful). I often went to a café in Charlotte Street before seeing the film. I always hoped to see a man there. I called him 'the café man.' He would be sitting near the back of the café. He had a small cup of coffee beside him, and he would be smoking a thin black cheroot while writing in a little notebook. He would look up dreamily while he took a drag on his cigarette, but he

never saw me. He had thick black hair and blue eyes and very full lips. He was obviously Jewish. There was a smug air of contentment about him, like the cat who had got the cream. He made me feel peaceful. I was to meet him many years later: Steven Kupfer, writer, philosopher, poet, is now my husband.

*

Lucian was a regular and frequent gambler. Often when he was on the phone, placing more and more extortionate bets on a horse, he would clutch me to him as I sat on his knee and I would hear his heart pounding wildly with excitement. We watched the races, after he had placed his bets, on a little television in a narrow room between his kitchen and his bedroom. The smell of rotting fruit and vegetable skins, mixed with old meat bones and cheese rinds from the rubbish bags that he kept in this room, added to the sense of the 'sin' of the gambling itself. As he held me tightly on his knee, Lucian knew that he was playing truant and that he

should really be in his studio, working. Once he won an enormous amount of money and he joked that he would buy me a diamond brooch, which he would fasten 'just here' – and he demonstrated with his fingers a place underneath the waistband of my skirt, where no-one could possibly see it. He more often lost, and on a vast scale. Then he was philosophical about it and said that he felt 'purged'. He would resume his work in a quieter frame of mind, until the next frenzied passion for betting overtook him again.

I wrote in my notebook, after one trip from Hull to London to see Lucian:

Lucian asked me to go down to see him on Sunday night at 1 a.m. I, like a sheepish fool, agreed. No hesitations.

His bell wasn't working so he said he'd linger around outside for me. When I met him he was far from welcoming, in a salty-white shirt, partly because some creepish man from the betting office had been hanging around him trying to extort money from him. So we went for a walk round the block trying to shake him off. We walked up through the dinky little mews (which I so often stare out at from his bedroom window) and finally reached his flat and the selfsame bedroom.

In the morning I went out to buy him some peaches and I found a buzzard's feather for him in the gutter. He had three samples of material to cover his sofa: a deep chestnut brown, a liver-grey and a smokier pinkish-grey. He had liked the liver-grey best until I said I like the smoke-pink-grey one and he decided I was definitely right on that score. That pleased me.

When I left I was weighed down by melancholy and even Constable's Leaping Horse couldn't part the clouds for me. He does not love me.

I caught the train home. I was so lost in depressive thoughts that I was completely unaware of any other passengers and was startled when a schoolma'amly voice said 'Are you ill?'

I started a painting of the ransacked whale of a tree in the garden in the pouring rain when I got home.

And now I must go to sleep.

*

Four sisters in my dream
Hold hands
And at my bedhead
Looking down
Own each a certain plot of land
Charted in grass
Of all I own
And time divides them
So that standing there
They are unaware
Of three blood-sisters
In the dark
With whom they share
Nothing
But the open stare
Of my memory.

*

Lying beside Lucian, I watched him sleeping. The breath worked its way gently through his lips, which made a quiet popping sound. Sleep always came to him instantly. I took a long time to fall asleep, my mind racing. I spent many hours watching him sleeping. All the drawings and the unfinished painting I did of him at a later date are of him asleep.

He had offered to sit for me for this painting (this was several years later, when I had my own space). He bought a beautiful slate-grey 'boiler-suit' (his description) from a hardware store in Shaftesbury Avenue. It fitted him tightly and he looked as sleek as a greyhound in it. He lay on a mattress in my studio with his fist tightly clenched up to his face: a familiar gesture. He boasted to Bella that he was now a member of the Models' Union, and he jokingly said to me that he envied me my subject matter.

I made a promising start, but the painting didn't work. I think I felt, at the time, that although I was Lucian's subject, he wasn't mine.

Eventually I painted over this start of a portrait of Lucian, first with the head of a woman; I painted over this portrait, too. The final painting to be conjured up on the canvas, which I know is a good and moving image, is titled 'Dark Night' and it represents the back-view of a little kneeling penitent figure. I painted it the year after Lucian died.

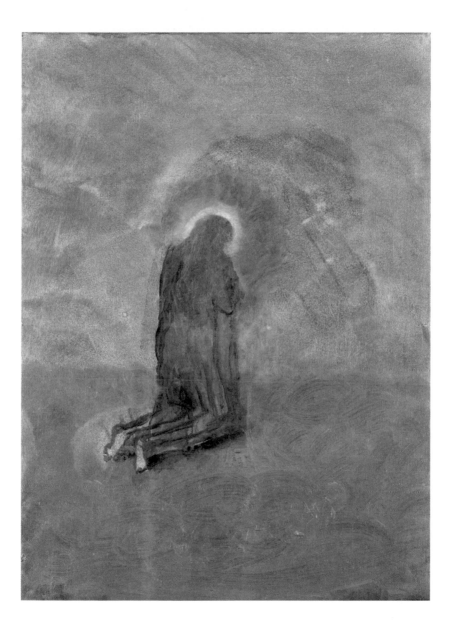

*

In the autumn of 1980, after I had finished my first 'Family Group' painting, Lucian asked me if I would sit for him. It was the first time I had sat for him, or for anyone, and I didn't know what to expect.

He asked me to take off my clothes and lie down on the narrow brass bed in his studio. The huge canvas that he had ordered for his own 'Family Group' formed a screen to the right of me; beyond the screen was a sofa, where he would place his models for night paintings. 'My' painting he worked on by daylight.

I was very self-conscious, and the positions I assumed for him were awkward and uncharacteristic of the way I usually lay down. I was never naked normally. I always wore something, even when I was alone. The experience of being naked disarmed me. I felt like I was at the doctor's, or in hospital, or in the morgue. I had drawn from naked dead bodies in University College Hospital morgue, as part of my life drawing studies at The Slade. I think I was more disturbed by the nakedness of the bodies than by the fact that they were dead. The old lady I had worked from had a purple-and-green bruise on her hip, but her hair was immaculately coiffed. It seemed sad and wrong that I was allowed to see her naked and with her bruise showing. I had never felt any awkwardness about asking my mother to take off her clothes, because she was so free and unembarrassed by her own nudity and she did it willingly, without any constraint. I was always inhibited and self-conscious.

Lucian placed the easel near the bed. He stood very close to me and peered down at me. I was very conscious of my flesh, and I felt myself

to be undesirable. Lucian instructed me to move about a bit on the bed. He told me to relax. I put my hand up to my face and cupped the other hand under my full breast. 'That's it!' he said. I knew that it was the way the skin of my breast rumpled under the touch of my hand that had attracted him.

When he first started the painting I was lying on the usual off-white counterpane. The first marks he made were depictions of my nose and mouth. He worked outwards gradually. He admired the 'rhubarb' pink of my fingers next to my face. When he came to painting my breasts, I felt his scrutiny intensify. I felt exposed and hated the feeling. I cried throughout these sessions. He tried to comfort me by telling me how much I pleased him. But I didn't believe him, because the evidence of what he really felt was on the easel in front of me. He decided to change the cover on the bed to a black cloth, so that the whiteness of my flesh would stand out more strikingly. When I thought he had nearly completed the painting he decided that he needed to place something in the foreground, so that the perspective of the nude would be more dramatic and intimate. He told me that my breasts reminded him of eggs. He boiled an egg and cut it in half and placed it on a white dish, which he positioned on the high stool that he used to put his turps-holder on. He made me lie in 'my' position while he painted the eggs in the dish in front of me.

He told me that he had written a poem about an egg when he was a little boy. He had rhymed egg with 'ugh' and had described how slippery the egg yolk looked, swimming in the white of the egg.

<div align="center">*</div>

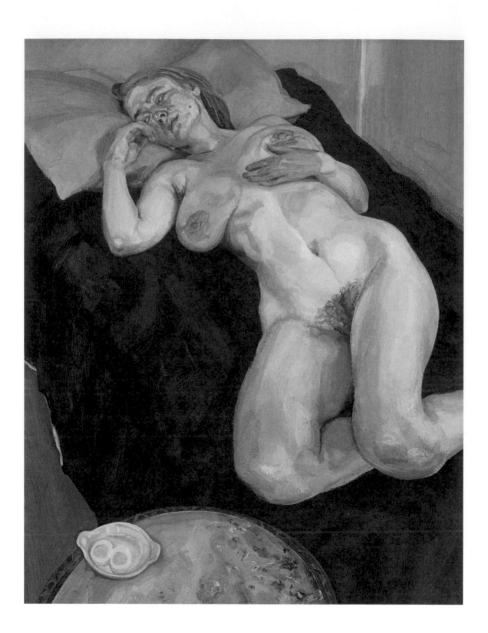

After spending the summer and early autumn in Hull, I needed to find a new room in London. I was beginning my last year at The Slade. The family that I'd lived with when I first came to London let me know that Father Lev ('the naked archimandrite') had recently died, and so his basement room in their house – St Basil's House – was now available. I decided not to follow Mary Bone's suggestion of finding accommodation through 'PATCHWORK', but moved back to the house in Ladbroke Grove.

<center>*</center>

St Basil's House, 52 Ladbroke Grove, W11
Dearest Kate,

It's Sunday and raining and I feel a bit morose and purposeless. I will think about Silk-Dress-Day which was the happiest day of my life (yesterday) to cheer myself up.

After buying the dress for me we returned to St Basil's House and I showed him the chapel and library which is lined with books on Russian and Greek orthodoxy. He said he wanted to scan the shelves carefully to see if there was an out-of-place book like *She Done Him Wrong* by Mae West.

Oh, and before coming here we went to a Greek restaurant and had some hummus. He spoke all about Greece. He said that good and bad characters are as clearly defined as black and white. He said he rather prefers the Shakespearean view of man – good and bad mingled and indistinguishable in each person. Except in certain cases, like the case when the psychiatrist said to his patient: 'This is no complex – you really are inferior.' He said much more, like how the Greek sun seems to preserve the colour in cloth

and furniture so that a regency chair is startling but that women start to go downhill at an avalanche pace from the age of sixteen etc. etc.

After the library I showed him upstairs – he is so observant and interested in everything. I suddenly visualised myself as I was when I first came here at sixteen and think how amazed I would be if I could see myself now, leading that great man up the stairs. There is this large thickly painted landscape in the children's bedroom. The whole thing is actually rather impressive apart from that disturbing circle of sky which appears through the trees and which seemed to have a face painted into it. He held up a toy frog's face lying on the mantelpiece and said that he thought the frog's resembles the face in the painting. Then he stuck this large piece of red plastercene [*sic*] up over the strange face in the branches and into this bit of plasticine I stuck a toy lorry. We stood back and it looked so funny. He said that a good title for the painting would be 'See You In A Minute, Barring Accidents'. He then played with a toy snake and made it lap up his tea.

I have just been to see him again today. He is so kind to me. I feel that I am being a bit over-confident and that he is withdrawing and retiring as I advance headlong. I am filled with a feeling of power because of his recent flattery and attention. I cannot understand why he is being so considerate and kind and I am suddenly the one to take shortcuts in his beautiful conversation so that we can sleep together. Perhaps he wants me to calm down. Perhaps it would be wise for me to clear off for a bit.

*

I went home for a while.

My father had been made Bishop of Bradford in April 1981. The new house was on a hill. My studio/bedroom looked out towards the Yorkshire moors. The room, with its views towards Haworth and the Brontë sisters, inspired me to paint some of my first mystical works.

My mother found the move to Bradford challenging, after the easier domestic arrangements of the Hull house. The house in Bradford and its surroundings were darker, bigger, untamed. The local people kept their distance. My mother often felt isolated. She was worried about my father, who suffered from headaches all the time and sometimes appeared to be depressed and to have lost his way. He talked to us less and less.

Back in London again, I started to think about putting together my best work from my five years at The Slade for my degree show. It was the start of my final term, and I was liberated by the thought that I would soon be leaving The Slade. The other students gossiped to me about Lucian and I felt trapped by the atmosphere in the life rooms. I wanted air and light.

The centrepiece of my degree show would be my 'Family Group'. I would also show a little oil study of my mother washing my sister Kate's feet: this was the only painting I had done from a photograph. The effect was very different. The energy of the paint marks was less free and urgent and more quiet and deliberate. There would be a self-portrait in front of the window in Hull, with my sister Kate and my mother in the garden behind me, two tiny figures. There would be a number of life drawings.

My best life drawings were of an Italian model called Lucia. I felt a special connection to her because, unlike the other life models who never showed their feelings, she wept one day because she said – just as my mother

had once complained to me – that she was being treated like an object. She felt degraded that none of the students talked to her during break times, and then just stared at her dispassionately as she lay on the filthy mattress. She was homesick, and lonely. My drawings of Lucia were better than my other life drawings because she dared to show how vulnerable she felt. I empathised with her because I had so often cried when I sat for Lucian, and I understood how an awareness of how exposed one is, when lying naked in front of someone, can undermine one's confidence, if one is made to feel undesirable.

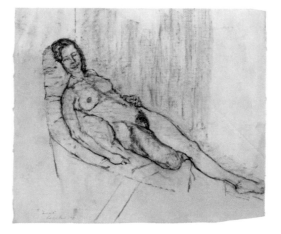

*

'The day he took me to Bristol was one of the best,' I recorded in my notebook:

We set off very early. We notice everything in the landscape flashing past us. He holds my hand all the time he is driving. I am very hungry. I say I feel

as if my stomach walls are closing in and he laughs and lifts up my dress and puts his hands on my stomach. We arrive in Bristol at eight-forty-five to the sound of Bing Crosby singing 'You are my sunshine, My only sunshine, You make me happy when skies are grey.' I guide him perfectly with my eleven-year-old memory, past the school, up Mortimer Road. He loves all the buildings.

We have breakfast in the Rodney Lodge. I think that our day is going to be doomed – everything plastic and smelling of institution. But then we walk out onto Clifton Suspension Bridge and I feel so perfectly happy. The view is spectacular. Grey and deserted. Stratas of woodland on one side and stratas of buildings on the other. My hair is tucked into the collar of my coat and he frees it for me. Then we look through the public telescope and focus on a factory in the distance. Then we walk back again and look in the shops in the Mall. He buys me some embroidered kid gloves from Beauvais. We then have coffee and Danish pastries. He loves my first school (which is just opposite the cake shop) and which is now the library. Unfortunately it is shut: Georgian, domed windows, perfectly proportioned.

Then we collect the car and drive down to the cathedral. I don't think Lucian is very impressed. He likes some embroidery framed on the wall. We go to look at the Norman Chapter House and are ensnared by the most tedious verger with a huge nuzzling dog and dozens of maps of Bristol, together with guide books. We think we will never get away. Lucian is very polite. We then go to see the docks which are very unimpressive and we have a drink in Ye Olde Berni Inn. Then we go to the museum and art gallery.

A very good Gaudier-Brzeska, Gainsborough portrait, marvellous Sickert, Courbet seascape. Lucian is very excited by them and he kisses me when we come to the Courbet. A warty dried-up man comes up to Lucian

and says, 'It's a humbling experience to be in a room full of such wonderful pictures, isn't it?' 'Yes, it is,' Lucian says. He is so polite.

We then drive back over the Suspension Bridge, down Beggarbush Lane, towards the sea. We are going towards Weston-super-Mare but I change my mind and we bear off down some very narrow rural lanes towards Clevedon. Very desolate. Grey sea, grey mudflats. We walk across the beach. We are the only people in the world. I love him so much. The sea is like the Courbet seascape we had just seen.

Then we drive home again. Everything is so easy. We arrive in London at four. It is still light. He hates driving at night so I am very pleased. We then go and have some hummus in Paddington and then come home. He reads the introduction to the copy of *Jane Eyre* that I have just bought him. We have a bath and then make love. He says how much I please him. Then we fall asleep. I have a terrifying nightmare about a tidal wave. I wake Lucian and he strokes me and says 'This is the anti-tidal wave squad' and I fall asleep again, peacefully.

*

Lucian had seen a painting by Watteau in the collection of Baron Thyssen, whom he was painting at the time. The painting is called 'Pierrot Content'. A white-suited Gilles is sitting in a wooded glade with two pretty ladies to his left and right, gazing at him adoringly. Gilles is smiling broadly, clearly in heaven. On the far left, with his hand on the left-hand lady's lap, is a wistful young man in patterned pantaloons. Another young man is reclining on the ground to the right of the right-hand lady.

The whole theme seems to be about complicated erotic cross-purposes. The painting is full of yearning. It makes me think of Shakespeare's *Twelfth Night*. It appealed to Lucian because of his own complicated love-life and the undercurrent of jealousy that I think he needed as a stimulus to his own affairs.

He had found the inspiration for his big painting.

For the first session, when he sketched out the whole composition in charcoal, it was necessary for all the models to be assembled. After that, I never sat with any of the other models apart from Bella, whom I was positioned next to.

I was to play the part of the wistful young man on the left and I placed my hand on Bella's knee, in a gesture reminiscent of the Watteau painting. Lucian had bought me a beautiful outfit to wear that he had got from an antique-clothes shop in Lansdowne Road. It was made of ivory silk with printed flowers scattered in random patterns. There were two parts to the outfit: a long skirt and a little bolero without any fastenings, which I wore over a primrose-yellow shirt.

Bella wore a coppery-orange dress made of a prickly material. It was embroidered with long vertical stripes of scratchy gold braid. She felt very uncomfortable in it. Lucian's stepson, Kai, wore pale linen trousers and a pale shirt. Suzy, Kai's mother, wore a purple blouse and a pretty flowered skirt. Suzy ran an old-clothes shop in north London, which she stocked with a wonderful array of garments that she'd collected from clothes markets. She, like me, had been at The Slade when she had met Lucian, about twenty-five years before me. She was to have five children, four of them by Lucian.

A little girl (the daughter of a friend of Kai and Suzy), called Miriam – or 'Star', as she was known – lay on the floor next to Suzy, and was the equivalent of the reclining young man in the Watteau painting.

Lucian's method was the same as with 'Two Plants': he would work intensely on a detail and the painting would gradually grow outwards from this point. With this painting, the first paint marks were built up from five disparate points as he worked on the five models involved. He started on the nose and the point on the forehead between the eyebrows, on all the figures, and then worked outwards. The forms grew bigger as he progressed, so that we appear to be squashing up next to each other. Despite the physical proximity, each figure seems locked into her or his private world and there is no emotional empathy between us. We look lost and isolated, like sheep huddled together in a storm.

Lucian and I were close at this time, and I knew that he cared about me. But I knew also that he was working from other people whom he didn't talk to me about. He was very secretive.

I made extended entries in my notebook:

His mood is brittle gentleness. I say one careless foolish word and he flings a hundred back at me, so angrily, so full of hatred, and then the ice-cold kindness seals the crack again and I am left feeling completely humiliated. Soon I lose my voice, my thoughts are covered in mist.

He talks to me about the impermanence of appearance and how it can only be made permanent by having a continuous moral fibre.

My lost voice, my thoughts covered in mist.

He tells me I am always being misleading. 'Either don't say anything at all or tell me the truth.' I obey him by doing the former.

He is angry with me because I was not at home when he had rung me to make weekend arrangements. If only he knew the reason why I am misleading.

I have experienced for almost three years the terrible agitation that he has felt with me for a night and half a day and the unbearable enervation and unease that it inevitably creates in one. The suspicions that swarm in the mind; waiting for something that may never happen and the great black fear of rejection. Those days in Ladbroke Grove when he had said 'I'll ring you soon' and I would be imprisoned in my room for a week. And then the phone would ring and I would see him for an hour and then go back to my cell of waiting.

That is why I mislead him and do not tell him the truth because, by lying, I can dance in and out of the prison bars and because he cannot catch me, he cannot sentence me.

Strange how the hold life has on me can seem so tight, so vigorous, and then suddenly so loose that it would need just one slight abstracted casual movement to slip it off from around my neck.

Lying in the bath, his beautiful body is encased in ivory in the evening light; my nervousness at his body's ease: his legs leaning apart against the white sloping sides. I turn away from him and look out of the window. The night is blind and kind to my agitation.

He slips away to bed on his own, a conspiracy of suffering between himself and his anger.

I come to bed a little later and lie on top of the covers. I pretend to be asleep, holding my breath in fear through the long night. And I hear all his gasping and the shouts which break him out of a quick nightmare. I have a nightmare too, a stealthy one, in which I have to prove my innocence to a court of justice in circumstances which point directly to my guilt.

When he wakes in the morning we make love with our eyes averted.

He is shining and grand and cruel today. He reminds me of what? Of himself and me some time ago. His position at the top of the steps so distant and half covered in a silver cloud, and I am somewhere way below, straining my eyes.

Looking at a catalogue of a Picasso exhibition. He points to one picture. 'I took that to Brighton once.'

'What do you mean?' I ask.

'Exactly what I say.' He shouts, looking at me as if I am dirt, and then sarcastically pronouncing each word very distinctly as though talking to a deaf and senile and very annoying old woman. 'I – took – that (points to the picture) – to – Brigh – ton.'

I am shaken by his harshness and my throat constricts. 'But I meant did you live there or was it to a gallery' (said with extreme difficulty through rising tears) and I cannot listen to the answer which I gather is spoken in a gentler tone of voice.

When we move to the studio, my tears start pouring down.

'What's the matter?'

'Nothing.'

'Oh, what's the matter?'

'I'm tired.'

'Oh, I do wish you'd tell me.'

'I am tired.'

'I wish you'd tell me the truth instead of always misleading me. I get so confused. You had a really good night's sleep, didn't you?' (Oh, sleepless, breathless night.)

I nod my head.

'Well then. I do wish you'd tell me!' (Very annoyed.)

I feel too stupefied by my feeling of absolute worthlessness to offer any reply. My tears had been started by his harshness but that was not the root of them. And then the tirade about my misleading him.

He tells me about his agitation about not being in when he rang me, but he says this is a very poor example out of countless others.

Again I have been to see him. He tells me suddenly out of the blue that he is going away to Deauville for a week or more. I make a fuss. Why doesn't he ever ever go with me abroad anywhere? He can't understand what a deep cut this makes in me. Thinks I am childish.

His diary is open and I see the name of a girl written in it. I feel everything becoming vague and nocturnal.

*

'Since the beginning of August he has been seeing her,' I continued in my notebook:

It is the morning of Tuesday 1 December. As I am leaving we arrange to meet at eight-thirty in the evening. He says he might be a bit late because

he has to go to a meeting. He asks me where I think I will go that day. He hugs me and laughs. 'Earls Court, I suppose.' [Earls Court preceded Soho as London's centre for gay and bohemian nightlife.]

I reply that I plan to go to the Sickert show but that I'm not sure what I would do after that. I think it odd that he asks me because he is usually so discreet about the way I spend my spare time. I think of the name in the diary.

After the Sickert exhibition I go to The Slade. A tank of tropical fish is on the table in the space next to mine and my friend is painting diluted watery shapes in time to the music of the air-pump. I think she doesn't look too absorbed in her work so I tell her all about my jealous suspicions.

She says, 'Would you like some heroin?'

We stand behind one of the screens and she finds a piece of silver foil which she tears in half; she rolls one piece up into a little hollow cigarette and keeps the other piece flat. Then she takes out of her bag a tiny square of folded paper, unfolds it, takes a little pinch of the powder and sprinkles it onto the flat piece of foil. Then she lights a match and holds it under the powder which begins to melt and go black. It reminds me of chemistry lessons at school. I follow the little trickle of liquid diligently with my silver pipe and breathe in the delicate smoke which tastes of incense and black treacle, and as I do so, I feel the emptiness and misery desert me and instead I am completely at peace and full of love for everybody, especially my friend who stands by me now and who I hardly know. We then take a bit of cocaine which I am unable to sniff up properly and I attribute this, for some reason, to my inability to swim under water, so I rub the remaining powder onto

my gums which become numb and remind me of the dentist. We then take more heroin and I am filled with more love than I know how to deal with. Then we are joined by another friend and her little nut-brown daughter and we all (not the child) smoke a joint. The little girl is lifted onto a chair to peer at the drugged slow fish in the tank. She is wearing a long brown woollen coat that reaches her ankles and she looks like a little Romany child.

Before going to have ice-creams at Bernigra's I go down to the toilets in the basement of The Slade and catch sight of myself in the mirror. I look very desperate. 'Yet I am filled with love,' I think. I am greenish-white and purple rims surround my eyes which are very pale with tiny shrunken pupils. I am abruptly reminded of my feelings of jealousy, and sadness again begins to leak in.

After finishing our ice-creams my friend and I decide to go to a bar in Soho.

We order our drinks and then sit down in the corner on one of the hard wooden benches. I look around me at the noisy group of drinkers.

Then I glimpse, moving away from the bar, between two conversing people, the averted head of a girl whose features are indiscernible in the smoky atmosphere and I know with absolute certainty that this was her.

I stand up, my legs are trembling, I can hardly walk. I call out to her. I am sure that she had seen me when she first came to the bar because she didn't turn round, surprised. She doesn't even meet my eyes.

She says 'Oh, hello,' looking down.

'I want to talk to you,' I say.

It seems as though there is only me and her in the world: the drinking conversing laughing people are superfluous to my purpose.

'Let's go outside,' she says, and I follow her.

We stand facing each other and I ask her straight out, hoping and praying that the answer will be no: 'Are you having an affair with him?'

And she replies: 'Something along those lines, yes.'

It's as though she held all my life, my trust, my self-respect, like a little glass paperweight in her hand which she now let fall, and only I perceive the tragedy of the shattered fragments.

She ruffles her blonde fringe and wears a compassionate smile. 'What's that for?' I wonder.

'Let's go round the corner,' she says.

I follow her like an automaton.

She is wearing a blue coat with a little collar of brown rabbit fur. Her untidy hair looks silver under the light of the streetlamp. She never looks straight at me but offers me her profile for my intense desperate scrutiny. I look at her with his eyes.

Her chin and neck form one smooth slope; her skin is peach-coloured and covered with a soft down; she has small blue eyes and neat little eyebrows (you notice neither); underneath her left eye is a small mole which she has accentuated with black paint; her mouth forms a sickle moon, scarcely any lips, and little white teeth.

She talks in a breathless voice beginning with an effusive rush and dying away on a half-finished word, with plenty of rufflings of her hair.

I fix her with an intense still stare.

'I've felt so guilty whenever I've seen you,' she says.

'I felt the only way I could make it seem all right,' she continues, 'was that I know he always has a lot of people at the same time. And I know I'm not the only one.' She is relentless.

'Look,' she says. 'You'd better go and talk to him now. He'll be in the bar any minute. We had arranged to meet.'

'I don't know how you could do it,' I say.

'I'm not the only one. I know about others.' Her voice dies away.

I have turned back in the direction of the bar to face him. I feel possessed, on fire with the most intense ambition: everything but this blazing ruthlessness is vacuous.

It is then that I notice a small nervous man in a new coat standing at the bar with his back to me. He starts at the sound of someone calling my name (I had forgotten about my friend). He hasn't seen me yet. I approach from behind and when I am quite close I move quickly forward and say to him: 'Could I talk to you, please.'

'Yes, what's the matter?'

My expression must terrify him.

We move outside and I start my second confrontation. The streetlamp shines and the street is deserted.

'I have just seen her and she says she is having an affair with you.'

'She didn't, did she?' he says.

His features assume an expression of terrible weariness and I feel infinitely tender towards him. I walk away but it's as if I'm fighting against an overbearingly powerful current pulling me back to him. I see my life without him stretching out like a lunar landscape and I turn back to see

him, a small silhouette, hesitant and unhappy against the bright lights of the bar.

He takes my hand and we walk on. I let my hair hang over my face and I stare at the dark pavement, the kerb, the road, the dark pavement. I feel him look at me occasionally. Pavement, kerb, road, pavement.

The taxis are scarce. At last one comes. I have to pretend to be reluctant while getting in. I cling to the far corner. He strokes my hair. It slightly eases the surface of my sickness.

'Tell me what you did today,' he says.

I cling more persistently to the side of the taxi and press my head to the cold glass of the window.

When we arrive at his house he is a long time paying the taxi driver and I stand shaking, staring at the ground. Eventually he comes and unlocks the front door and we go silently up the dark stairs.

When he opens the door of his flat, the light from the heavy crystal chandelier is dazzling. All my hysteria had been acted out under cover of night punctuated only by the dim streetlights and I had sobbed with my head down, screened from him by my hair. But here I am, lit up, an actor when the curtain rises – and I have already played my part.

I feel momentarily inclined to pretend that nothing had happened: to take off my coat, have a glass of water and ask him if he had had a good day. And then I think of what would naturally follow: we will go to bed and I will be confronted with a lurid picture of him making love to her. My jealousy surges up again and leaves me shaking.

'Would you like a drink?'

'You lied to me.'

'It doesn't alter what I feel for you.'

'It does for me!' I cry out the words. 'I used to really believe in you.'

'Oh, please still do!'

'I don't know how you could do it if you care about me.'

'That has nothing to do with it.'

'And know how I feel about it.'

He was looking happier, I notice.

'I don't think it's right.'

'I don't know if it's right and I don't know if it's wrong.'

'You lied to me.'

'When did I actually lie to you?' He is very gentle to me.

'When I asked you if you were going with anyone else you said – of course not.'

'Oh yes,' he murmurs. 'You know I almost always tell you the truth.'

'How can I know when you're telling me the truth and when you're lying to me? Perhaps I should go away and forget about you.'

'Oh, don't. Oh, please don't.'

He takes my hand.

'I can make it all right,' he says. 'It's only the love-making that worries you, isn't it?'

I nod my head and cover my face with my hands.

He laughs gently and puts his arms around me.

'You're crazy,' he says. 'I can make it all right, like you want.'

I go and sit down on the kitchen chair, unreassured.

'Will you look at my new coat that I got this afternoon?' he says, buttoning up a modest, well-cut overcoat with subdued brown and grey checks.

He parades it shyly for me.

'It's very nice,' I remark. 'I did notice it before but didn't mention it, under the circumstances.'

He comes and stands behind my chair and I know that means bed.

We make love and he is very tender with me. I hold his head in my hands.

He says: 'I am dreaming I am lying with you in Regent's Park.'

I remember that day soon after I had first met him when we had gone to Regent's Park where we had lain on the grass and looked at the gulls, and he had said, 'I'm sure those gulls have never seen the sea.' And he had untied my skirt and kissed my waist and then my lips.

I don't sleep all night. I lie shaking with emotion.

He sleeps only fitfully and on waking each time he draws me to him and my tears run onto his chest.

The streetlight below throws the shadows of the geraniums on the windowsills onto the ceiling and I watch them throughout the night. They look like the amorphous shapes of blood cells under a microscope. I watch them fade as dawn approaches.

'Do go to sleep, Celia, it's almost morning.'

He holds my head onto his chest and I almost drift into sleep but start awake as if frightened by something. He strokes my hair. Then he guides my hand down. I draw my hand away. I lie far away from him. He turns away from me and pulls the blankets up around him. I cry loudly and then come up to him and hesitantly put my arms around him. He pulls me onto him.

'I can't!' I cry out. And then, 'You can make love to her later on if you like.'

'You know that's not it,' he replies.

'What is it then?'

'It's really not what you think.'

He is nestling against me. We make love but I feel inadequate. I am filled with a dull despair which is more sincere than last night's drama. We get up and my eyes feel very swollen with crying.

I begin to negotiate in my mind the possibility of living without him and feel relieved by my indifference.

When he asks me if he can ring me on Sunday, I reply with sincerity that I don't want to see him for a while as it makes me feel too sick. He asks me if he could write. I nod. Then he says, 'Oh please can I ring you on Sunday?'

I hesitate then say, 'Yes.'

'I wish you would not go with her but I suppose you have to.'

'I told you I wouldn't. And I won't.'

'Will you ring me on Sunday?' I say, halfway down the stairs.

'Yes I will,' he calls down.

And I shut the front door behind me.

When he rings we make it up of course, and I am wooed by him saying 'I feel really married to you.' And because he had not slept since seeing me and had had asthma very badly.

The recoil of having given too much away.

He is very pleased to see me at first. He says how nice it is to see me after such a long time because it puts everything into perspective. I don't know what he means. A compliment. Then we sleep and sleep and sleep.

When, on leaving, I say that I will miss him so much, he says, 'Oh, don't! Just miss me the right amount!'

*

A rose by any other name
Like love unnamed
Between those who love, who hold the rose,
An unnamed
Flower. Anonymous love, a rose
In the beak of the unknown bird
Falling in shadow on the flowers stirred
By an unseen wind. White flowers unknown
Bridled in fields:
Bent heads in disarray broken
Would smell as sweet
As red roses sent as token
Between those who love, who know the rose,
A message certain,
Free in couplets uncertain with no wedlock
Their shadows in fields drift behind them to the edge
Peopled with the white sweet-smelling heads:
The flowers; watch their broken image
Mirrored in the surf below,
With bare feet, unchained and unwedded,
Their shadows drift like kites above them.

Home

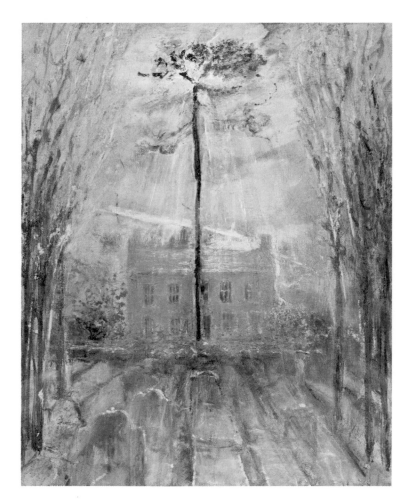

Bishopscroft, Ashwell Road, Bradford

Dearest Lucian,

Here is the letter I said I would write.

I am very sorry I am so bad at telling you what is bothering me.

I think that in London you have been the only person who is important to me, so that in between seeing you I have lived in constant anticipation of seeing you again and I have been unable to do anything because of wondering who you are with and wishing you would come and visit me.

That is why I thought that by going away there would be no hope of being with you and I would be able to concentrate on work. I am stimulated by the thought of London but have always felt too much on the edge of everything to work very sincerely. Coming home to my family is in a way a solution.

I know you never force me into anything. I sit for you because I like doing it and because I admire you. It's just that I would like to come to you

without this feeling that my life is a waste of breath apart from being with you.

I have been working all day on my mother's head, trying to do something that will take me completely by surprise when I catch a glimpse of it accidentally. This means that I have to make my mind blank when I come back into the room because anxiety makes me shock-proof. I haven't got anywhere yet but I think it will be all right.

I am banking on there not being a mist today so that I can paint the hill (my mother is busy). There is mist on the hill two days out of three so I am backing a slightly doubtful horse.

I am eating all the right things so that I can be very well for you.

Lots of love,

Celia

*

The Bradford house looked towards Haworth, where the Brontë sisters had lived, and, on the other side, towards the city of Bradford. The lights used to twinkle in a lonely way at night as the three of us, my mother, father and me, sat in the uncurtained sitting room. My four sisters were away from home.

My mother woke me every morning with a cup of tea soon after five. She would then sit for me for three hours until it was time for her to join my father for morning prayers in the little chapel on the ground floor of the bishop's house. She would have breakfast with him and then sit for me until

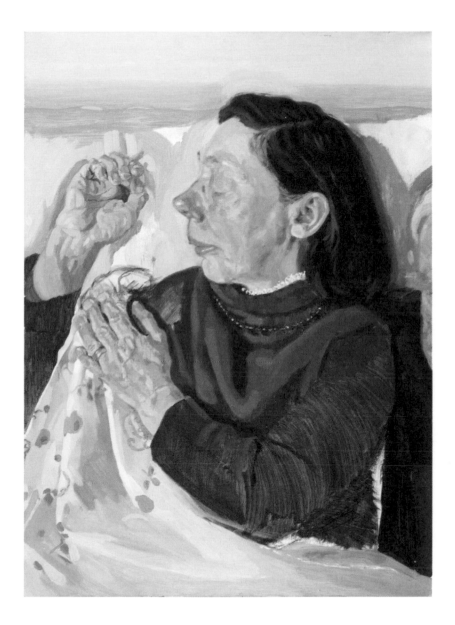

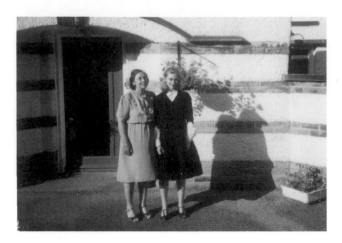

lunchtime. In the summer, while the light lasted, she would sit for me again in the afternoons.

<div align="center">*</div>

I wrote to Kate (who was now a student at Oxford, reading English):

Here I am on my own. I have brought up Ibsen's *Ghosts, War and Peace, The Way of All Flesh*, and Yeats' poems. I have my picture in my studio which I am yearning to get on with – my whole life in two rooms. I had a nightmarish beginning to the painting. Mum's head turned away in the shadows – I was completely unable to control it at all. I find it so difficult to paint shadow on skin but here it was hell – brown on slime on more slime, the drawing lost. So I turned the whole thing round so that Mum's face is facing the light and it all became more possible. But then Mum had to go

to London with Dad and she left me itching to get on. I think this painting will go on inch by inch for well over a year, leaving me in a state of continual agitated suspense – Mum keeps having to go away and Dad will never be free. If only I could work on several paintings at the same time.

Darling, if you can possibly lay your hands on last week's *Sunday Times* colour supplement PLEASE do so – it has the most breathtaking details of 'The Last Supper' by Leonardo – more beautiful than I can say. It has made me long to do something great. I think I might touch on it if only I could work harder.

*

I painted 'My Mother with a Ring'. My mother rested her head against the vertical slope of the sofa and she held her hand, with its wedding ring, beside and in front of her face. In the painting she has a look of intense sadness. Her eyes are lit up and tear-filled. The painting is entirely illumined by the flame-coloured cloth that I draped over the arm of the sofa, and everything is reflected with firelight.

I followed this painting with 'My Mother with Shining Eyes'. Her eyes received the light in a unique way, quite unlike mine, which glitter all over the surface when I'm looking into the light. Her eyes hold two little stars, one in each eye, little dazzling pinpoints. In the painting she is wearing a deep purplish-red dress with a flounce down the centre. I had seen Titian's 'Entombment of Christ' at an exhibition at the Royal Academy and I longed to use a similar rusty-red in a painting. My mother has a pleading expression, as though she is seeing a vision and is pleading for help.

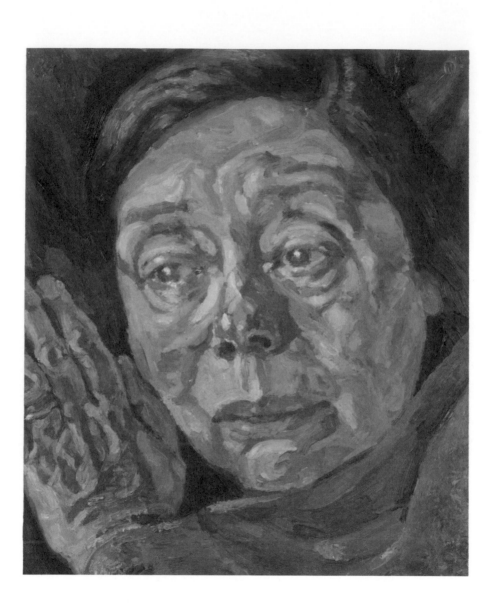

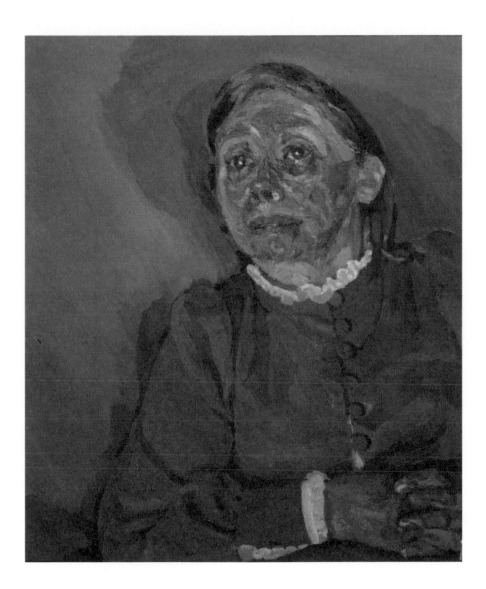

I read a story about St Brigid in a book of women saints that I had. St Brigid had performed the miracle of giving a blind woman her sight for a split-second. The blind woman had seen fields with cattle grazing in them. The scene was so beautiful to her that she said the split second was all she needed, and that the memory of it would light up her life for evermore.

I was moved by the story: the ordinariness of the vision making it especially poignant. In my painting, it is St Brigid herself who has the vision. St Brigid is the Irish saint of cattle and dairy. She seemed the fitting saint for my mother, who was a nurturing child of nature, in my eyes.

My mother lay down on the sofa in my studio and I painted the backdrop of the moors with grazing cows that I could see from my studio window, behind her.

I was thinking of a painting that had affected me deeply in an exhibition of Spanish painting at the Royal Academy; it is by Ribera and titled 'Jacob's Dream'. Jacob is darkly clad and lying down in the foreground of the large canvas. He has his eyes closed in sleep. Rising up behind him is a Turneresque mist, through which you can make out the form of a ladder pointing heavenwards, with angels like little birds climbing up it.

I loved the way that the down-to-earth was juxtaposed with the visionary: it was a juxtaposition that I needed to explore myself.

*

I grew closer to my father. I was reading *Our Mutual Friend* by Dickens. I started calling my father 'Pardner', the name that the sneaky Riderhood uses to address his victims and accomplices.

My father loved Schubert song cycles and Mozart operas, Handel and Vaughan Williams. His voice would break if he quoted from Matthew Arnold's 'The Forsaken Merman': 'Children dear, Was it yesterday?' Shakespeare's plays were profoundly important to him. He adored Robert Browning and G.K. Chesterton.

His favourite painter was Van Eyck. I think it was the purity of intention that he loved, as well as the clear colours and cold clarity of the northern light.

Lucian had given me some money to buy my father a book on Van Eyck for a birthday present. I went to Zwemmer's bookshop on Charing Cross Road. There was a beautiful book on Van Eyck. But I also saw a beautiful book on Carel Fabritius, with the painting of the goldfinch on the cover, that I wanted to buy for Lucian. I couldn't afford both books. I saw a book on Rodin that I could buy, as well as the one on Fabritius. I gave my father the Rodin book, but mentioned the Van Eyck. He was sadly disappointed, though he did admire Rodin.

One of my father's firm convictions, apart from the significance of the reality of the risen Jesus Christ, was that it was an essential part of Christian faith to belong to the Church. In his inaugural sermon, on the occasion of his installation as a bishop, he had preached: 'There is no way of belonging to Christ except by belonging gladly and irrevocably to all that marvellous ragbag of saints and fatheads who make up the one Holy Catholic and Apostolic Church.' It was this point of view that was so antipathetic to my own nature. I had always hated the thought of joining in. I hated the implication that some people were included, while others would be excluded. But the depth of his conviction was moving in itself, and I wondered about his certainty.

I tried to do a painting of my mother and father together, but my father was not a good sitter. He would either fall asleep immediately or else suddenly jump up, remembering something he must do.

One morning, at the time I was expecting my mother to bring me the five o'clock cup of tea, she came into my room with a frightened expression and said, 'He can't move.'

When I went into my mother and father's room, I realised from his face that he was seriously ill. He was lying on his back with his mouth and eyes wide open. His eyes were fixed in an unblinking stare. I called out loudly, 'Hello, Pardner,' and thought I could detect a faint responding gleam of recognition in his eyes.

Very gradually he began to gain awareness of his surroundings, and he slowly moved his mouth. He needed the toilet. He was a broadly built man, although not fat. My mother and I struggled to get him up from the bed – he was very heavy. My mother and I supported him as best we could, but before he could get to the loo, he slipped to the floor. I tried to raise him, but he cried out in pain. He then wet himself and the urine soaked his pyjamas and flowed over the lino. He stayed there while my mother called the ambulance. I will never forget his expression as he was being carried down the stairs by the ambulance men. He smiled slightly, but his eyes were infinitely sad.

My father was told that he had a tumour, the size of a large tomato, in the back of his brain.

My father who, up until then, had always been reluctant to sit for me, now presented himself as a willing sitter. But it was too late. I never finished the painting; it didn't work, and I painted over it eventually. An official portrait was what he had in mind, to hang in the Chapter House in Bradford Cathedral

along with all the previous bishops, looking proudly out from the ornate folds of their regalia. My father's portrait would have looked wildly out of place.

He was broken down by illness. He sat down on the sofa in my studio, looking out at the Yorkshire moors, and the tears streamed down his cheeks. His eyes looked dark and enormous in his wasted face. He told me that he was thinking of the Beloved Disciple and of Christ's words to him from the cross. How Christ told the Beloved Disciple to take care of Mary, Christ's mother, after his death.

My father went into hospital for surgery, which was successful, but he caught pneumonia and was rushed to intensive care. It was July 1983. There was a seemingly endless heatwave: every day the sky was an unbroken blue.

At 2.30 a.m. on the morning of 10 July we were woken by a phone call from the hospital informing us that my father had just died.

When the dawn broke, we saw that a dense mist had settled over the whole surrounding landscape. The mist didn't lift and the rest of the day was dark, with no sign of the sun that had been blazing throughout the previous weeks.

<p style="text-align:center">*</p>

There followed a time of great uncertainty for us all. My mother was allowed to stay in the Bradford house until she found somewhere of her own to live. My father never owned any possessions, apart from his books, and he left her no money.

I finished the St Brigid painting. My mother lies on her side, with her eyes closed. Her hand, with its wedding ring, is on her chest. She is wearing an

olive-green jumper and a silky pleated blue skirt. On her feet she is wearing red shoes, with a little upward tilt, reminiscent of Persian shoes. Behind her are the hills of the Yorkshire moors with peacefully grazing cattle; the highest peak is at the central top of the canvas. I was thinking of Rembrandt's 'Polish Rider' in the Frick Collection, which I had seen a reproduction of. I thought it was such a solidly constructed composition: the way the head of the rider is placed in vertical relation to the pyramid of the mountain behind him. I had wanted to do something to echo it, using the same sheltering edifice of the mountain, like a tent, to protect my mother. I was thinking of both Rembrandt and Ribera when I planned this painting. My mother is dreaming up her own protective world. She is the spirit of nature.

<p style="text-align:center">*</p>

Lucian had bought me a flat in Bloomsbury in 1982. I hadn't worked or stayed in it much while my father was alive but, since his death, I had started living there permanently. The bigger of the two rooms, which faced onto the forecourt of the British Museum, became my work space.

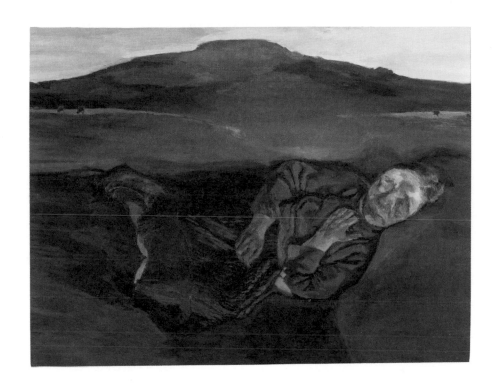

On a dark day in mid-December 1983 my four sisters, my bereaved mother and I gathered in my studio in Great Russell Street. I had moved my brass bed into the studio and I positioned it in front of the tall mirror that Lucian had given me. My sisters and my grieving mother sat on the bed in silence. The gas fire purred gently. I sketched the composition in charcoal onto the canvas.

My mother had become withdrawn, a thin shadow of herself. In the painting she sits in the middle of the group of strong women – her daughters – and she is the one who needs protection most of all. She is our child.

The painting was to take me more than two years to complete. The paint is very thick and the image is pervaded by a feeling of grief. The five women look lost and alone, drifting on a lonely raft, without a navigator and longing for guidance. My mother is gazing out beseechingly at the viewer, from the centre of the 'raft'. She looks very vulnerable, despite the attempt at courage signalled by the bright checks on her skirt.

There is a deep empathetic connection between them all. They are sharing the loss and huddling together for warmth and protection.

*

The Church put out a petition and enough money was raised for a small property. My mother said that she'd like to live in Cambridge, where my father had studied as a young man and where he'd been very happy. She would be near my sister Jane and her husband Rowan Williams, who was to be made the Dean of Clare College, Cambridge. Jane found a small terraced house for her close to the River Cam and Midsummer Common.

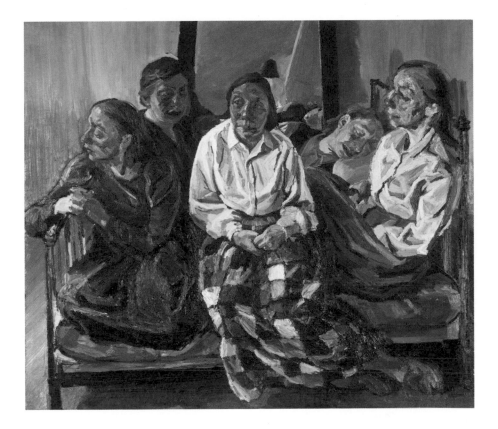

Being a Mother

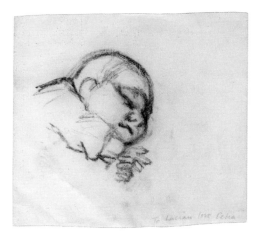

To Lucian love Celia

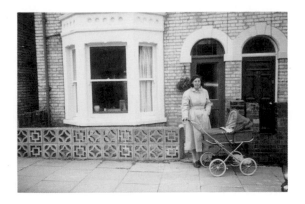

When I gave birth to my son, my mother willingly became his main carer. She offered to look after him in her house in Cambridge so that I could continue to paint.

I wrote in my notebook:

My emotions on seeing Frank's face for the first time are the most powerful I have ever experienced.

I do not know myself. I do not know who I am. He knows who he is. His certainty in this knowledge of himself gives him power over me, tiny as he is.

Everything he does, every movement, is right. I am frightened by my clumsiness. He is fragile and infinitely precious.

What is expected of me? He knows what he needs from me. He takes my milk and my protection.

I would like to give up everything for him. I would like to be swept away and lost in this powerful tide of maternal love. I would like all my ambition and all my desires to be drowned with me.

But some contrary instinct is working in me at the same time: I must save myself too. Think of my painting, all I have achieved and all I hope to achieve. Think of Lucian. Will our love be the same as before?

This instinct is like an ant that has been stopped in its tracks by a giant object dropped suddenly in its path. The ant is momentarily bewildered. How do I get round this obstacle? The obstacle is the enormity of my love for Frank.

<center>*</center>

I tried to work out a strategy. I needed to rearrange the structure so that I could accommodate the three purposes of my life: Frank, my work, Lucian.

I had loved being pregnant. Lucian had started calling me 'Seal' (short for Celia) and I became 'Seal and Baby Seal'. He bought me an electric easel, to make it easier for me to adjust the height of my big canvases as I worked on them. There was a switch on the crossbar bearing the canvas, which you flicked to move it up or down.

I painted my mother lying down, and I left a gap between her arms where I would paint my baby. My 'Family Group' painting was developing and growing, in unison with my pregnancy.

My mother bought a Babygro with an apple on it, because I intended to call my daughter Eve. I assumed I would have a girl, because of all my sisters, and because Lucian had had mainly daughters. It was a thrill when the scan showed it was going to be a boy.

My mother was excited to be looking after a boy, after so many daughters.

As the due date drew nearer, my mother came to stay with me in my flat. I slept in the brass bed in my studio, the one on which all my sisters and my mother sat for my big painting. My mother slept in the bed in the next room.

It was December now, and very dark and cold. In the evenings my mother and I sat together on my wooden chairs, trying to keep warm by the gas fire in the sparsely furnished room that my mother was temporarily sleeping in. The lights from the British Museum cast their long shadows onto the ceiling.

During the night of 8 December 1984 (Lucian's sixty-second birthday) my contractions started. My mother and I made our way cautiously down the stairs and out into the cold street to hail a taxi to the hospital.

My labour lasted until just past midnight on 10 December. Frank was facing the wrong way. The consultant thought that the force of my contractions might adjust Frank's position and that I could then give birth naturally. But this didn't work. The pain was intense. I was given an epidural, but the effects of this eventually wore off. Kate (who had joined us) and my mother were with me in the delivery room. In the end I had to have an emergency Caesarean, so I was unconscious when Frank first appeared. Kate and my mother saw him before I did.

I loved Frank from the first moment I saw him: a fierce feeling, unlike any love before. I hadn't realised that he would be a 'person' when he was born, but there he was, looking at me and apparently engaging with me. He felt almost uncannily familiar to me, as if I had known him all my life. His features resembled Lucian's, but his expression was different, in that he looked at me directly: he seemed to feel at home with me, too. My mother

often related in years to come how, on the day after his birth, Frank had looked first at me, then at my mother and then at Kate, as if to find out what sort of company he'd been landed with.

I didn't want to be parted from him. The nurse took him away from me on the first night after the birth, to give me a chance to rest. The big room where they placed the babies, in rows in little cots, to allow their mothers some recuperation time, was across the corridor from my room. I recognised Frank's voice amid the other voices of the crying babies and I rushed to retrieve him. He lay close to my breast all night, his cheeks very red from the heat.

Lucian visited and brought me a bottle of champagne. He was nervous of holding the baby and surprised that the nurses all knew straight away that he must be the father, because of the physical resemblance. When he hugged me, he was taken aback by how 'skinny' I was: 'Where's that baby gone?' he said.

Frank Auerbach visited too, bringing a present of an exquisitely woven soft wool shawl. He told me that he had only recently visited this same hospital because Kitaj's wife, the artist Sandra Fisher, had given birth

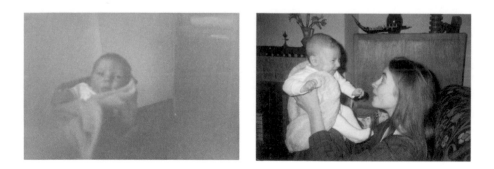

to a baby boy, named Max, a few weeks earlier. Julia Auerbach gave my Frank a toy frog made out of green velvet (which he later became very attached to).

I stayed in hospital for five days, and then friends of my mother drove me and my baby back to her house in Cambridge, which she had prepared with a cot and a pram for Frank's arrival.

I had no trouble with breastfeeding. One night when Frank was quietly feeding, I had a strong sense of the rightness of the world and of my peaceful place in it: 'This is *it*,' I said to myself. But I knew that it couldn't last. The health visitor said that I couldn't mix formula with breast milk and so, if I intended to go back to work, I would need to stop breastfeeding.

After just three weeks in my mother's house I went back to my studio in London, to my painting and to Lucian. Frank's face was in my mind all the time and I missed him painfully. Lucian was disturbed by the milk that had leaked onto my dress: 'What's that?' he asked. I sensed that it repelled him.

When I returned to Cambridge I wasn't allowed to breastfeed, even though Frank cried for me.

My 'Family Group' painting progressed and the feeling in it deepened. I painted Frank into the space that I had prepared for him in my mother's arms, in the lying-down portrait of her.

My dedication to my work was unshakeable now, but I was always tired, anxious and distracted. My mother was often exhausted, too, and sometimes resented the long hours she spent on her own with her grandson, though she loved him passionately.

When Frank was two months old, I fell briefly in love with an eighteen-year-old Cambridge student who I met on the train. I was twenty-five. We went to concerts together and the theatre. I felt that a new dimension was being added to my life.

But I was still deeply involved with Lucian. I simply loved him more. My attachment to the Cambridge student passed after three months. Lucian, however, spoke of Rodin's hurt when he no longer had complete control over his lover, Camille Claudel. Lucian said that he understood how painful that feeling is.

*

Lucian had started a painting of me in a blue-and-white striped nightshirt that he had bought for me. It was a comforting garment to wear, very soft and loose. He had started this most tender painting of me before I got pregnant, and he finished it when Frank was nearly a year old.

Lucian was very loving to me throughout my pregnancy, but he found it difficult to deal with the fact that I was preoccupied and not so readily available after the birth. In the last months of sitting for this portrait, a gap started to open up between us. Something in me had changed. I felt more powerful and confident since becoming a mother. I was beginning to have more of a sense of who I was.

In October 1986 I had my first solo exhibition at the Bernard Jacobson Gallery in Cork Street. It was very successful and got a lot of attention. Saatchi bought my recent 'Family Group' painting, as well as 'My Mother as St Brigid, Dreaming' and a number of other works.

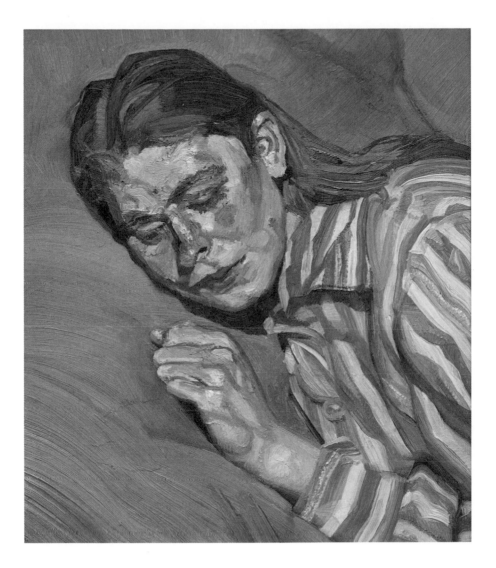

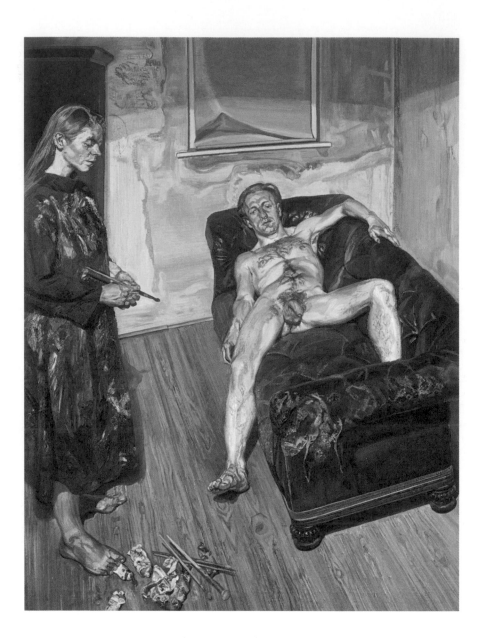

The last painting Lucian did of me, which he started soon after my exhibition, was about power and desire. He asked me to wear a red dress covered with paint marks, which he had seen me wearing when he had visited me. In my studio there are half-squeezed-out paint tubes lying around on the floor. Lucian, who was always much more meticulous than me – he collected his used paint tubes on a little metal trolley on wheels in his studio – was interested in the way I nonchalantly trod on the paint tubes as I walked around my studio. He restaged this drama in his own studio. He wanted my feet bare, so that my toes, which were pressed onto the paint tube, would be more allusively dramatic. Lucian asked me to hold the paintbrush in my hand, and he suggestively angled it to target the naked man lying with spread legs on the sofa in front of me. The naked man was my friend Angus Cook, the writer and artist, whom I had met when he was studying English at University College while I was at The Slade. He had often sat for me. Lucian had seen a drawing I had done of Angus, which had made him long to paint him.

This painting, which Lucian titled 'Painter and Model', reminds me of an earlier painting of his: the one where his mother is seated vertically in an armchair in the foreground, and at her feet is a pestle and mortar. Behind her, in an erotic trance of abandonment, is a naked woman: his lover at the time.

The mother dominates the foreground with her powerful presence. The pestle and mortar is such an oddly surreal object to have been placed at her feet in this marked way, so that one is made to think about its implication. It seems to me to correspond to my phallic toe on the squirting tube of paint.

I felt honoured that Lucian should represent me in the powerful position of the artist: his recognition was deeply significant to me. But

underlying my pride, I felt wistful that I was no longer represented as the object of desire.

Lucian went on to paint some of his most erotic and tender paintings of Angus, and then with Angus's partner at the time: the artist Cerith Wyn Evans. Angus and Cerith introduced Lucian to their friend Leigh Bowery, the performance artist. The paintings that Lucian was to do of Leigh would be the most ambitious works he ever did, and on a monumental scale: Leigh became Lucian's main sitter until his death from AIDS on New Year's Eve 1994.

Angus and Cerith sat regularly for me as well, most often at night. During breaks from sitting, the three of us would right all the wrongs and injustices in the world, and we would always end up in tears. We laughed a lot, too.

*

Lucian and I were drifting apart. We met regularly, but I sensed he was preoccupied and that he must be in love with someone else. I found out that he was involved in a very serious relationship with a woman, and that the affair must have been going on for a long time. In fact, without my being aware of it, she was seen by most people as the main person in his life. I had been displaced. In February 1988 I decided to split up with him.

*

Painting is the language of loss. The scraping-off of layers of paint, again and again, the rebuilding, the losing again. Hoping, then despairing, then hoping. Can you control your feelings of loss by this process of painting, which is fundamentally structured by loss?

In order to make a great painting you need to destroy paintings. There is no real way of 'saving' them. You may be pleased with a painting, or part of it, but in order to go deeper you need to scrape the image down or wipe it out, completely. I am often haunted by lost images – paintings that I've destroyed and that will never be resurrected – and I can torment myself with the memory of them.

Painting has a unique relation to time. A painting that has been done quickly has a different energy from a painting that has been done slowly. A painting that has been done quickly is like a newly decorated room and the air is fresh, empty and echoing. A painting that has been done slowly is like a room that has been quietly lived in: it acquires a mysterious stillness.

Painting is the most personal art form: it is like a handwritten letter, with the character of the artist's 'handwriting' adding to and enriching the message.

Painting is like the hand-print on the prehistoric cave wall.

Words and images are so closely connected in our minds, from our earliest attempts at language. The image is on the right-hand page, the word for the image is on the left.

When you are overpowered by loss and grief, you stare at the image, almost uncomprehendingly, not knowing or caring about how to define the thing you see. Words slide out of focus, sometimes right off the page.

The image always seems to me to be 'it': the thing that you need to find a word for, the unfathomably mysterious absolute.

Before starting to paint, as I try to do every day, I need to prepare myself: I need to feel still and focused.

My Mother

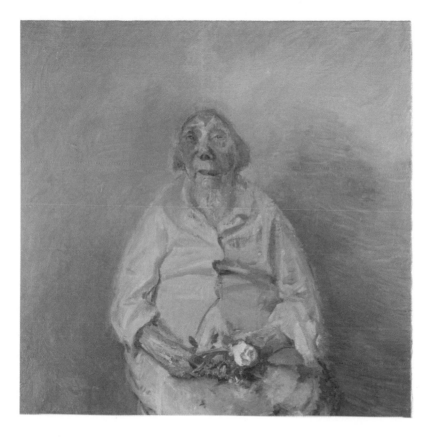

My mother no longer had any hurt feelings, she no longer thought that I was treating her as an object when she sat for me, as she had done when I first began to work from her. Maybe I grew less domineering and bossy with her as I grew more confident of her willing participation. She used the time of silence for prayer: 'What a gift for a Christian,' she said. She would travel down from Cambridge Tuesdays and Fridays to sit for me in my studio in London. She was always anxious about the journey and, very often, she didn't sleep the night before. She would invariably arrive at my flat soon after 8 a.m., having caught a train earlier than planned. She was always very dishevelled and breathless on arrival.

I would wait at the door of my flat and listen to her gasping as she laboured up the eighty steps. She would stop frequently and I would hear her groaning. I would call out, 'Are you all right?' She would cough loudly and then resume her laborious ascent. She would be too exhausted and out of breath to speak for the first few minutes. She would collapse into my battered wood-framed chair in my front room, with her bags scattered

all around her. She looked as if she'd just fallen from a great height into the chair and all her clothes and possessions had exploded on impact. She would close her eyes, then slowly come to and ferret in one of her bags for the croissants she had bought from the shop down the road. She would then tell me all about the adventures of her journey that morning and the conversations she'd had with the people on the Cambridge train.

After we had drunk our tea and eaten the croissants it was time to start work. I had placed her sitting clothes on my bed: a pale cotton shirt, very faded and almost white, though it had once been peppermint-green, and a long white skirt with an elasticated waist that my sister Lucy had made out of an old sheet.

I changed into my paint-encrusted painting clothes. I waited for her in my studio and called out, 'Ready when you are!'

My mother often liked to have her feet bare when she was sitting. Often, especially later, her ankles and feet would be swollen after the journey, so it felt more comfortable not to be wearing shoes. I watched her anxiously as she trod heavily across the floorboards towards the red chair in the corner of my studio. I worried that she would tread on a splinter. She sometimes did, but it didn't seem to bother her much. Once she was seated, the room would become very silent as I picked up my brush and began to paint.

Sometimes the silence of that first session was oppressive to her and she would feel faint. She was cross with herself that she couldn't enter into the experience straight away, because her mind was still jangled from her journey and a sleepless night. We would have a little break and go into the other room. Sometimes I was very irritable with her. I had just started to get into the painting and I felt frustrated. I became tense and cold to her, which

upset her. We would sit without speaking for a few minutes in my front room. She looked green with faintness and sat with her eyes closed. Then she would rally herself, have a sip of water, then splash her face in the sink in the bathroom. She said that her eyes felt as if they had been sandpapered. When she was reinstalled in her sitting position in the studio and I had resumed painting, she entered into the silence with her soul. Her face assumed a rapt expression. My painting was raised to a higher level, too, because of her elevated state. The air was charged with prayer. She was always ecstatic if she felt she had sat well.

We would work until twelve-thirty and then she would get out of her sitting clothes and prepare for her departure to King's Cross and the train journey back to Cambridge. She would gather up her various plastic bags and sling her rainbow-coloured woollen bag over her crooked shoulder. My heart ached as I said goodbye and watched her rounded back as she made her way slowly down the stairs, gripping the bannisters nervously as she went. I would look out of the window and watch her as she walked away from my flat, a hesitant but determined little figure among all the crowds of tourists outside the British Museum. I could still see her as she walked down Great Russell Street, until she reached the street that led into Russell Square, and then I would lose sight of her.

*

My mother was born in Stonebridge Park in north London. Her father, Frank Watts, was a railwayman. Her mother, May, suffered from rheumatoid arthritis and her hands were crippled claws that hurt so much she found

it hard to hold my mother's hand. My grandma attributed the early onset of the disease (it developed in her mid-twenties) to the discovery that my grandpa had 'terrible swings of mood' and often refused to speak to her for a week at a time. She told my mother that the main reason she had fallen in love with him was because he made her laugh.

When my mother was born, my grandma said that 'a little ray of sunshine came into the room'. My mother was named Pamela Maisie. When she was five they moved to Harrow Weald.

The house in Harrow Weald had always seemed to us girls 'home' when we came back to England on leave from India. And later Kate and I used to visit often during the school holidays. It was a mock-Tudor terrace in the north London suburb. I used to go there sometimes from The Slade to stay in my mother's old bedroom, and I painted my grandma after Grandpa had died. It had been soothing at night to listen to the trains travelling to and from Euston, where my grandpa had worked as a porter.

My mother had often talked to us about the times she spent in North Crawley, a picturesque village in Buckinghamshire, with her Aunty Nellie and Uncle Bill. She stayed there when she was a little girl, and during the war (she had been twelve when it started) she was evacuated there from London. Her Uncle Bill was head gardener at The Grange, the big house in the village. He and Nellie had a little cottage with a pretty garden. My mother said: 'I was allowed to sit in the garden, if it was summer, by the wallflowers where the bees were buzzing and there was a Victoria plum tree. That was a blissful time.'

My mother's happiest memories were from that time, and she often thought about the trees and flowers in the North Crawley garden to help

her get to sleep at night. But a terrible tragedy happened there, which was to haunt her for the rest of her life.

Aunty Nellie got typhoid fever and had to go to hospital. Uncle Bill needed somebody to look after their little boy, Kenny, their only child, while he went to work, so my grandma and my mother went down together to Crawley. My mother was four years old and Kenny was two and a half. He was a beautiful child, with platinum-blond curls and dark eyes.

One day my grandma needed meat from the butcher for lunch, so she wrote a note and gave my mother a basket. Kenny wanted to go with her and they walked along the lane to the main road. At the junction there was a bend in the road that led away from the village towards Cranfield. Just as they reached the end of the lane they saw a woman called Lizzie Wright on the other side of the main road. In the pocket of her apron she had an apple, which she took and held out and called, 'Come on, Kenny, here's an apple for you!' And Kenny let go of my mother's hand and dashed across the road. Just at that moment one of the very few cars ever to come down the road turned the corner and knocked Kenny down.

My mother's next recollection was of Kenny lying in his cot in Nellie and Bill's house. Kenny kept thinking that he wanted to go to the loo and they put him on his potty, but only blood came out of him because he was badly injured internally. And at some point in the night he died. My mother remembered his little coffin in the hallway, covered with flowers.

My mother did well at school and won a scholarship to Harrow County School for Girls. From there, she went on to study English at King's College London.

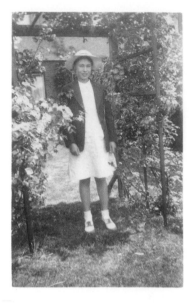

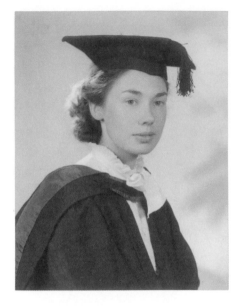

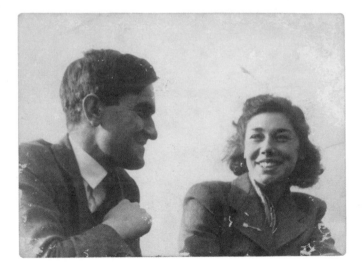

*

My father had been born and grew up in Wimbledon. He never spoke to us about his life, but I think his father worked as a clerk in an office. At eighteen, my father won a scholarship to Cambridge, where he studied French and Spanish. When the war started, he first of all decided that he would be a conscientious objector but, as Hitler's campaign intensified, he felt that wasn't right. He was made a Royal Navy liaison officer on a French ship under British command. His experiences during the war were traumatic. The only time he ever fainted was when he had to help the ship's surgeon with an eye operation on a man who'd just been shot in the head.

During the war, and while he was away, he heard that his mother had died suddenly. He never told us how she had died.

When my father returned to Cambridge at the end of the war he was changed by his experiences and felt that he needed to switch subjects: he decided to study theology. His faith deepened and he felt called to become a priest. His training involved further studies at King's College London.

My mother had started going to the Christian Union meetings at King's, not because she had suddenly found she'd had a dramatic conversion, but because she liked the people. Soon, however, she became fascinated by it all, especially the Bible studies. The head of theology at King's wrote to the Christian Union people and said, 'There's this marvellous man who's coming from Cambridge, Geoffrey Paul. Do try to get him to come to your meetings.'

He formally proposed to my mother on her twentieth birthday. She had invited a few friends round to her home. He came up to her room, where she

was looking for a book that she thought might interest him, and he suddenly said, 'Miss Watts, I think I would like to marry you.'

My mother and father were married four years later. After leaving university they attended a missionary training college, and then my father went out to India on his own. My mother didn't see him again for nearly two years.

They were married in Colombo, Sri Lanka, and then travelled to the theological seminary in Kannammoola, a suburb of Trivandrum in Kerala, south India. They would live there for another thirteen years.

My mother described to me how, when she first arrived in Sri Lanka, she was wearing a little straw hat that her devoted mum and dad had bought for her as protection, but, as she stepped off the boat, she realised the hat wasn't going to give her any protection at all and she was nearly knocked down by the heat.

My mother told me that, on their wedding night, my father said he didn't think he could love her properly, because the war had damaged him emotionally. Their early married life was difficult, according to my mother, but they loved each other. My mother often felt homesick and alone, but she never doubted that she had married the right person, and she was certain they would spend their lives together.

<div align="center">*</div>

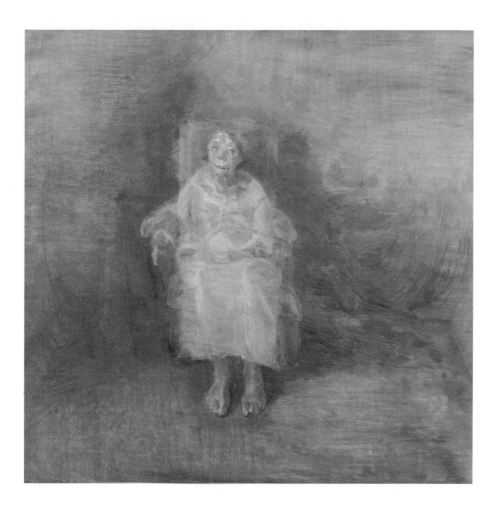

My mother holds her five-year-old grandson in her arms. He looks at me directly and puts his little fingers onto her hands, which are clasped round his waist. He leans back against her and his legs hang either side of her lap. His solemn gaze is fixed on me as I paint. The clear, straight look is characteristic of him and has been a defining part of his nature since he was a baby. I felt cowed by my love for him. I felt that it might be wrong and suspect for me to be standing looking at him, where I had placed him, lower than me on my mother's knee. I should have been the one who was sitting. I sensed that he felt this, too, and that there's a trace of indignation in his regard, and a hint of hurt pride. I wasn't sure that I was getting a likeness of him. I felt too deeply connected to him, in an underground kind of way, to know what he looked like. Everything that he was experiencing reverberated through me, too. Shockwaves of pain coursed through me when he was hurt or upset.

My mother told him stories in her purring voice. He snuggled into her and was comforted. My mother's love for her grandson was as strong as a mountain. The years had chiselled and focused her need to give love. Her body was a fortress. No harm would come near him. My gaze unified them and gave them a sense of holy complicity. I thought about Rembrandt's etching 'The Virgin and Child with the Cat and Snake'. I was like lonely Joseph, looking in through the window.

*

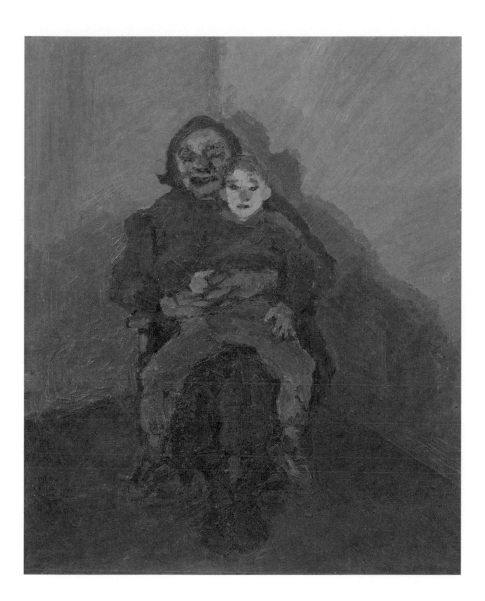

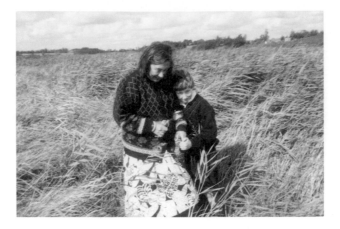

My mother, Frank and I walked through the whispering reeds, our footsteps silent on the wooden walkways. The air was alive with the calls of seabirds and there was a bracing sea wind. We couldn't hear the waves, because a parapet of shingle formed a soundproofing barricade between the marshes and the sea. I walked ahead, carrying my painting equipment. I needed to squeeze out my paints onto my paper palette and install myself before my mother and Frank arrived, shortly afterwards. I told them how to sit and they positioned themselves according to my directions.

I had found a reedy hollow, away from the path, for them to sit in. I crouched down among the reeds to watch them and to paint. Frank curled up next to his grandmother's soft, comforting body. She looked like a lioness protecting her cub. I was also reminded of the painting by Corot of Hagar and Ishmael, Abraham's wife and son, who had been cast out by Abraham at the command of his new wife, Sarah, to wander in the desert and fend for

themselves without Abraham's help. In Corot's painting, Hagar and Ishmael are two tiny defenceless figures in the lonely rock-strewn wastes of the desert. Hagar is stretching up her arm to heaven, desperately pleading for help. The prostrate body of little Ishmael is beautifully realised and reminded me so much of my own Frank. In Corot's painting, a tiny angel is flying down to offer Hagar a helping hand. No such help is on hand for my mother, Frank and me, except for the love that bound us and strengthened us.

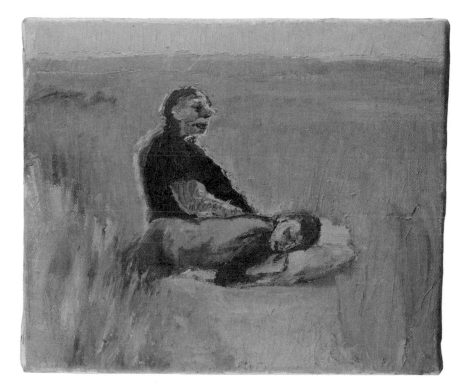

Frank liked to listen to story tapes on a cassette player. We listened to *Great Expectations*. The Suffolk marshes echoed the desolate setting of the Essex marshes, where Pip's encounter with the convict Magwitch takes place.

For Frank, Walberswick still holds an important place in his memory: 'I remember when I used to lie in that sunken grassy patch by the side of a cornfield in Suffolk, while the morning dew crawled gently into my tracksuit. My gran lay beside me; her body always seemed so strange to me, so soft but yet so heavy and powerful. Her walk was a slow but determined

shuffle and her breathing was unhurried, noisy and regular, like waves against a shore.

'I lay in the grass, torn between my desire to impress my mum, by lying as still as I could, and my desire to rebel against the unfairness of the belief that a young boy should be made to sit motionless for what seemed like hours on end, just because he had suffered the unfortunate fate of being the son of a painter.'

I was aware that Frank often found sitting for me arduous and boring, but I continued to make him do it. He was compliant and would very naturally assume the correct pose at the start of each session. When he became a teenager, his reluctance hardened and he refused entirely to sit for me. Once, while he was asleep on the sofa in my mother's house, when he must have been aged fifteen, I was drawing him in my sketchbook. He woke up and caught me out. He was very angry. But before he became a teenager, he forgave me for my demands on his time. Between sittings we played together and were very close.

We were staying in the Hidden Hut in Walberswick, which had once formed the summerhouse of the bigger 'Hidden House' next door, divided from it by a hedge. Ernst and Lucie Freud, Lucian's parents, bought the property for themselves and their three young sons in the early 1930s, soon after they first came to England from Germany. The Freud family had been accustomed to spending summers on the island of Hiddensee, off the Baltic coast. 'Hidden House' would be their English equivalent.

In the evenings at the Hidden Hut I would light a wood fire in the sitting-room hearth, and Frank would cuddle up next to me on the sofa. My mother sat opposite in a big armchair. The three of us watched the flames

in the grate and we were gilded by firelight. On one occasion the front door wasn't firmly shut, and a ginger hen wandered in from the garden.

It was while we were staying in Walberswick that I heard of the death of my school friend, Linda Brandon. We had become close again ten years after we had separated, and she often sat for me. In 1991 she was diagnosed with breast cancer. A year later, in the summer, I rang her from a phone box on Walberswick village green. I got through to a recorded message which she had left for me, saying that she was about to go into hospital and that she didn't expect to survive.

*

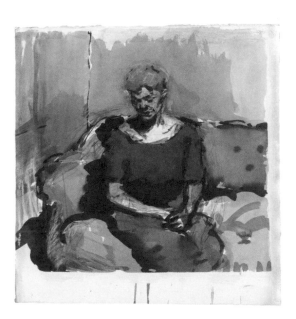

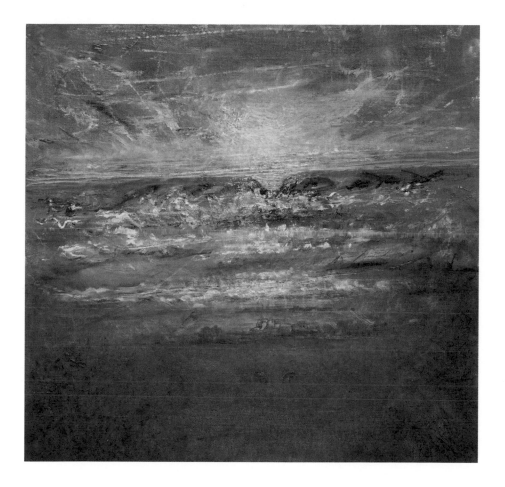

My mother was to live in her house in Cambridge for another thirty-two years. She had been fifty-six when she was widowed and she was eighty-seven when she died on 11 February 2015.

The last study I did of my mother was a little pencil sketch of her face. She was in a nursing home. She had lost her bearings. She was fractious and constantly fidgeting, her hands forever plucking at the sleeves of her cardigan and the collar of her shirt. She kept asking, 'Why won't anyone tell me what I'm doing here?' I kept saying to her that Frank and his girlfriend Masha (who were her carers and lived in a flat round the corner from her house in Cambridge) had found her lying down in the hall, where she had passed out. I didn't tell her that almost as soon as she was admitted to hospital she became very confused. She said to one doctor, when she was introducing me to him, 'And this is my darling mum.'

The dementia set in and she was never her true self again. She quickly lost mobility and had to be helped with everything. Frank and Masha wanted to look after her at home, but we all knew this would be impossible, because she needed at least three people to help her get washed and dressed. She kept pleading to go home, but the home she had in mind was her childhood home in Harrow.

The last coherent words she said to me were: 'It is Celia, isn't it?'

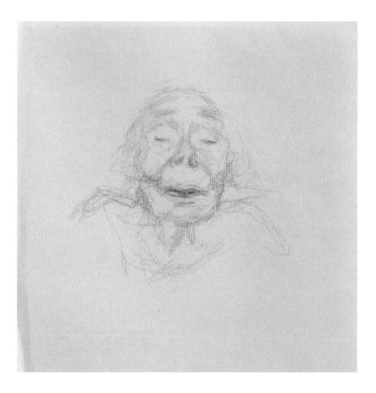

My Sisters in Mourning

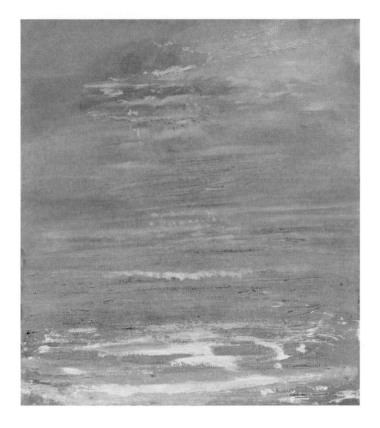

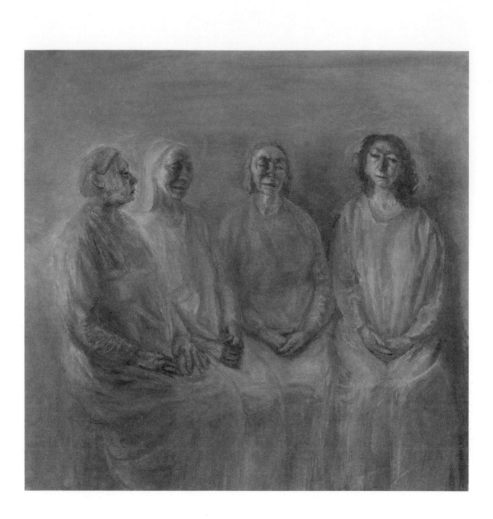

The school that my three older sisters were sent to when we were in India as children was high in the hills in Ooty. Each sister started school at four years old. It was most difficult for the eldest – christened Rosalind Miranda, but always called Mandy – because she was the first, and therefore alone.

I remember the journey to school when my father, mother, Kate and I used to be taken there by a hired driver for visits. To get there you had to drive up a road that wound around the mountain like apple peel. You left the dry, dusty heat of the valley further and further behind as you made your way into the cool, forested shade at the top of the high peak. Getting out of the car when you arrived at the school, you felt that you had entered another world. It had a sort of magic. The air under the pines was muffled, as if it had been silenced by the soft pedal of a piano; the ground was thickly carpeted with pine needles, which deadened the sound of your footsteps. The air was clear, cool and scented with pine. There were dips and hollows, and everything seemed secret and shadowed.

My older sisters were wild with excitement to see us and they darted about, playing mysterious games with each other. They screamed and shouted, and I was frightened by them and felt they were out of control and that there would surely be some accident, and that they would be inconsolable. We would have to leave them there crying, and the last sight of them as we turned the corner away from the school would be too heartbreaking to bear.

<p style="text-align:center">*</p>

Ever since I had completed the big 'Family Group' painting after my father died, I had been planning the painting that I would do after the death of my mother. I foresaw that the inconceivable pain of that eventuality should somehow be commemorated and transfigured. I wanted to do a painting the same size as Matisse's 'Le Buisson', which measures 149 x 149 centimetres, because I have never seen a painting where the scale was so harmonious with the subject, and because I wanted to represent my sisters as being almost like a rosebush – each an individual bloom, yet united by the stem and roots of family history that they shared.

On 10 July 2015 my four sisters put on their white dresses (made for them out of old sheets by my niece, Alice Archer) that I had laid out for them on the bed. I had positioned the dresses so that their embroidered initials in the neckline were visible: R, L, J, K. My father had died on 10 July thirty-two years previously. The occasion marked a double commemoration. I had imagined that we might all be amused to see ourselves apparelled in white, but instead we were moved by the significance of the drama.

They filed into my studio, where I was waiting for them, standing at my easel and almost invisible to them, as I peered out at them from the edge of my big canvas. They sat in the chairs that I had placed for them, in order of age: Rosalind, Lucy, Jane, Kate.

I needed them to sit for me all together because of the supernatural empathy that ran like an invisible skein between them. The silence was powerful and charged with spirit, almost as if we were in a seance, conjuring up the spirits of the dead.

Mandy was sitting nearest to me, her profile haloed in the golden light from the window. In the painting her head is held high and she seems to be navigating her way out of grief. She told me, after the painting was finished, that in the first months of sitting she was filled with anger at the lack of information and support that Mother had received from the Health Service for her dementia. It had come as quite a shock to Mandy when a care-worker, in a recovery care unit after Mother's fall, had said, 'You do know your mum has Alzheimer's, don't you?' Mandy felt that nobody had ever told us what might be happening to Mother, or how we could help her. She had felt sure that I must be picking up on the anger that she felt as she sat for me.

But then she said, 'Gradually, as the months went on, the sittings developed into a time of peace, where there was a way to just sit and be quiet.' She is a priest in the Church of England. Sometimes she would use the time of silence to prepare her sermon for the following day. And sometimes she said she was 'just sitting saying a prayer that is known as the "Lord Jesus prayer": Lord Jesus, Son of God, have mercy on me. And just sitting there saying that over and over again, which is like a mantra for Christian meditation, led to a great sense of inner peace.'

Lucy is next to Mandy. Her face, half turned against the light, is in chiaroscuro. Her silver hair is lit up and her right eyelid and forehead are brightly illumined. She is looking down and is withdrawn into herself.

Lucy, a teacher and child counsellor, when speaking about the experience of sitting, said that 'sitting itself is quite a strange experience.' She often felt hemmed in: 'You get the sort of physical discomfort, which is anything from an itchy nose to a feeling of acute claustrophobia.' Sometimes she felt anxiety about sitting so close to her sisters: 'There's the heat, and there's the feeling of blurred outlines as well, the sort of colours all seeping into each other.' She concentrated on keeping 'her distinct outline', so that she could 'go into a kind of reverie, which is the best experience of sitting.' And she added how important it had been for her to sit with her sisters for me, for this particular painting: 'I think that otherwise we would all have drifted off into outer space. She sort of brought us together.'

Jane, a theologian, is placed between Lucy and Kate, and is in shadow. She appears aloof and quietly self-contained. Yet she said that she found the start of each sitting difficult. 'I always find when I come in at the beginning it takes a while to get used to being looked at like that. Because obviously I'm used to Celia looking at me, talking to me, interacting with me. But it's very different just to sit and have her look at you almost like an object, in a way, with a withdrawal of that relationship between us. And so I find it's easier normally, when I'm sitting with the other sisters, because that gaze gets sort of spread a little.'

She was also worried by the fact that I hadn't put myself into the painting, and she thought about the reason for my absence. 'I wonder if what she's actually picking up is her own sense of loss, that she's talking about something that's missing from the family dynamic and that's perhaps

being represented by her absence from the picture. I mean she's clearly present, because she's the one making it and creating it, and interpreting it and translating it, but she herself is not going to be visible in the picture. And I'm finding that really quite hard to live with, actually.'

Kate, a writer, the youngest and my most frequent sitter, is sitting next to Jane. She is 'there' for me and her sisters. She appears to be actively thinking and caring about us. She was thinking about Mother, too: 'There's one way that, for me, I can almost physically be aware of her, and that's through my hands.' She sits with her hands clasped and she can feel her wedding ring. 'The hand I knew best and that was most familiar to me throughout my childhood, and right through to the end of her life, was of course my mother's hand, with its ring; and although her hands changed as she grew older, they always had a familiar feeling; and I remember holding her hand on the day she died and it still felt just the same.' Kate thought about her own hands: 'My hands are changing, too, and becoming more like hers in later life.

'And I'm reminded in this painting of us sitting side by side of one of Beckett's short plays: it's called *Come and Go*, and there's three women sitting next to each other of "indeterminate age", and you find out that they've known each other since they were children. And at the end they all hold hands and one of them says, "I can feel the rings", even though Beckett says in his stage directions "No rings are visible". And of course you could interpret that line in different ways, but for me, I am always reminded of the rings in a tree, the hidden record of time passing. And I think this picture is rather like that; it carries the record of all our past lives and, of course, possibly foreshadows future family group paintings that we don't yet know.'

The painting is grey and muted. The dresses are like shrouds and ash-coloured. The silent sisters are sharing their grief. Everything is seen as though through a cloud of smoke and ash. I didn't want to break the unity of the group by putting myself in the painting. I would have had to represent myself reflected in the mirror, in the act of painting. I would have looked too active and disturbed the silence.

*

After my mother died, everything seemed in flux. All that had been structured and consoling before had broken up and dissolved. The only meaningful subject appeared to me to be water. I felt that time itself was like water, a powerful current that had dragged my mother away and that was also pulling me in the same direction. There was some comfort for me in this thought.

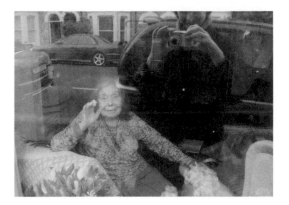

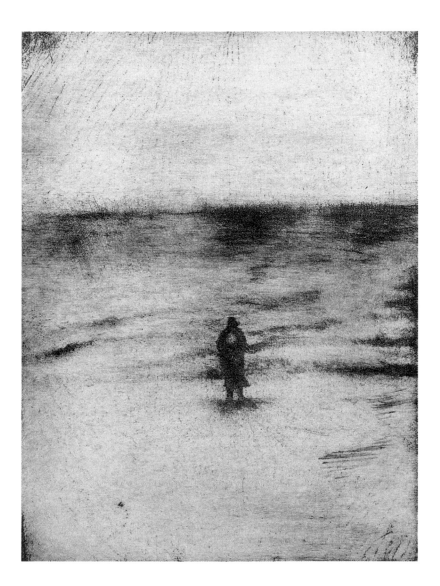

I made studies on the beach at Lee Abbey. I watched how one can clearly see the wave as it approaches, and the traces of it as it is pulled back again by the drag of the tide, but that when the wave was actually in the process of breaking, it is impossible to witness what is happening in the chaos of splintering water. It made me think about how impossible it is to live fully in the present. I recognise the impossibility, but also the necessity of trying.

I made studies of the waterfall that courses its way through the steeply banked woods and over boulders until it joins the beach, where it fans out and trickles towards the sea. I thought of my mother's life. I thought of her courage and spirit and her powers of endurance.

I made studies of a little brook beside a house in the mountains in Pembrokeshire, where we have stayed regularly for holidays since my childhood. I made watercolours of the little spout of water between its ferny bank as it plumes into the pool below. I did a study of the same stream after a night of torrential rain, when it had turned into a roaring flood that burst its banks. I thought of grief and of how it can't be contained.

Painter and Model

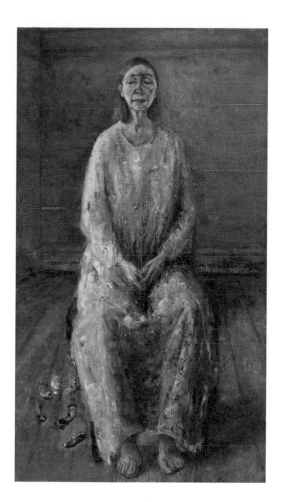

After I split up with Lucian in February 1988 I didn't see him for nearly two years. During this time I noticed that the colours I was using became darker. I felt like I was working my way out of a tunnel, and it often seemed as if I was labouring on without any hope of finding my way.

When Frank went to school in September 1989, and was happy there, something lifted in me, too. Even though my mother was his main carer, I was actively involved and needed to travel to Cambridge every other day to see him. But after he started school, my mother was free again to travel twice a week up to my studio in London. I went back to Cambridge at weekends. The new, unbroken rhythm of this routine was liberating and suddenly my painting came alive again.

I felt that it was important for Frank to have contact with his father, and now I had enough confidence to start seeing Lucian again, mostly with Frank. They understood each other and they shared a similar surreal sense of humour. Throughout the rest of his life Lucian was a regular presence. After his death, on 20 July 2011, I needed to address what his absence meant to me.

In 2012 I did a painting titled 'Painter and Model', as a reference to the last painting Lucian did of me with the same title, and which he had finished in 1987. I painted myself as an artist's model, seated and with my eyes downcast. My bare feet and the squeezed-out paint tubes that litter the floor relate to Lucian's painting in which, following his instructions, I had placed my bare foot on a tube of green paint.

But the dress I am wearing, in my own painting, is overlaid and dripping with paint: it is my painting dress. The mood is sombre and the colours, slate-grey and mother-of-pearl, have an affinity with Gwen John, as well as sharing something of her interiority. I am, like her – she famously posed for Rodin and was passionately involved with him – both painter and model.

And now, especially after the death of my mother, I am my own subject.

My Studio

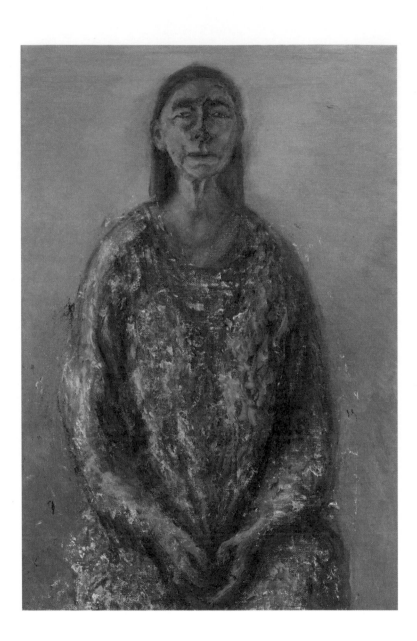

The flat that Lucian bought me in August 1982 has hardly changed since the day we first saw it and were astonished by the great windows looking onto the forecourt of the British Museum.

The flat is high up, on the fourth floor, a climb of eighty steps. The nearly empty rooms serve the purpose of being receptacles for the light. I am on a level with the figures on the frieze on the front pediment of the British Museum. The little figures of the tourists in the forecourt look as tiny as ants, in comparison. When I wake up, the first things I see from my bed are these huge figures of the Muses carved into the triangular summit of the pediment.

I am on a level with the topmost boughs of 'my' plane tree in Great Russell Street. It appears to me to be a spirit of endurance and hope. Its slender trunk bears only the slightest warp under the strain of supporting its load of twisted branches, heavy with seedpods round as pom-poms. In the winter, when its boughs are bare, I can see the BT Tower rising up behind it. The sky in London has a unique grandeur. You can sense the

spirit of the Thames river, and of the sea, in its vast watery, light-reflecting clouds.

The two rooms facing onto the British Museum are my bedroom/sitting room and my studio. These rooms face north-north-west. There is a particular quality to a north-facing room, which I always recognise and feel connected to. The air is never disturbed by sunlight and retains an intact silence. Here, the seal of the silence is broken only on a summer evening when the setting sun steals in and throws long shadows onto the walls. The noises from the street drift up and are a constant sound-installation. The quality of the sound changes at night, becoming more staccato. The creaking of the museum gates, as a worker arrives for night-duty, is a soothing sound. The streetlights throw spidery shadows onto my ceiling.

Sometimes, on a bright night early in the year, I see the moon hanging low, very close to the BT Tower, and the moon and the tower seem to be communing with each other in an alien language. On a bright, cloud-free morning in February or November, when the sun is low in the sky, the light from the rising sun is reflected in the glass at the top of the BT Tower, forming a dazzling spotlight, which throws the quivering shadows of the branches of my plane tree onto my bedroom wall. It feels like a mystical experience when this happens: a visitation.

I keep the blinds down in my studio all the time. I need to keep the silence intact and undisturbed by the light. It distracts me when I'm working if I glimpse activity outside my window. The floorboards are bare and saturated with paint and turps. My painting clothes and paint rags have turned into encrusted rock formations, due to the numerous layers of paint marks where I have wiped my brush or my knife.

I have written instructions to myself in charcoal: 'NO HIGHLIGHTS …
KEEP TONE DOWN …' The corner of my studio, where my models sit, is a
hallowed space.

The back of my flat has a different feel. It faces south and is often sun-
drenched. Pigeons nestle on the windowsills. My kitchen looks out onto
rooftops and the spire of St George's, Bloomsbury. I can imagine that King
George can see the sea from his little tessellated pyramid of a spire.

When the full moon floats in the sky, facing south, it makes me think of
romantic sea voyages. I think of Shelley, who spent his last night in England
in a house in Great Russell Street, before setting off for Italy where he was
to die so young. I think of other spirits who have lived nearby: W.B. Yeats,

Virginia Woolf, Charlotte Mew, William Blake, Vilhelm Hammershoi, Gwen John, Walter Sickert. I am inspired by the visionary legacy of the place.

My flat is sacrosanct. No-one can enter without my permission.

*

I write in my notebook:

Kate is going to sit for me today. My alarm clock goes off at 6 a.m. I make myself a cup of tea and I drink it in bed. I gaze at the floodlit pediment of the museum. The lights throw a complicated network of shadows onto my ceiling. I watch the shadows vanish as the daylight strengthens and the museum lights are switched off. The street is quiet until the guard at the museum gate loudly greets one of the nightworkers as they leave from their all-night shift. Then silence. An occasional car goes by.

I get up and put on my painting dress, the same one that I wore in my painting 'Painter and Model' and that is now stiff and brittle with dried paint marks and has assumed the texture of hardened papier-mâché.

I take Kate's 'sitting dress' out of the cupboard in the hall: the long white dress made out of sheet and that she wore for my painting 'My Sisters in Mourning.' I place the dress on my bed for her to change into when she arrives. I arrange the dress so that the stitched 'K' on the inside of the neckline is visible.

I go into my studio and prepare the paints on my palette. I used to have a wooden palette but it grew too heavy for me to hold as the layers of scraped-off paint accumulated over the years. I changed to a paper palette where I can tear off a 'page' of the palette after each use. I squeeze out blobs of

paint onto the paper: Payne's Grey, Vandyck Brown, Naples Yellow, Brilliant Yellow, Cobalt Blue, Chrome Green, Raw Umber, Burnt Sienna, Alizarin Crimson, Flake White.

Kate's chair is waiting for her in the corner of my studio, near the window. I have drawn lines in paint on the floorboards by the legs of the chair to mark where it should be positioned. The chair is in the same place as it has been for many years and it was exactly in this marked space that my mother sat for the last paintings I did of her.

I move the easel into the middle of the room so that it is positioned in front of the chair and some distance from it.

I move the little wicker and wood chair, which bears my palette, my pot of turps and my long brush, and I place it next to my easel.

The sounds from the street are becoming louder. Already a few visitors to the museum are beginning to gather outside the gate. The recycling van pauses for a long time on my side of the street. Its engine throbs noisily and sharp clangs vibrate through the air when the bins are emptied into it. Further away, I can hear the first plaintive strains of the accordion player who has taken up a daily position on the corner of Great Russell Street and Montague Street. It is the one instrument that doesn't disturb me when I'm working, and I have noticed that the dreamy notes can sometimes help me to conjure up dreamy paint marks in my sea paintings. Occasionally, a violinist takes up her stand outside the main gates of the museum. I find the sharp notes very distracting. I have been tempted to give her money to go away and sometimes I have harboured longings to throw something hard at her from my studio window. But today, luckily, she is absent.

I go into the kitchen and I fetch cups, tea, milk, kettle, and I bring them into the front room where the chaise-longue, chair and bed, with Kate's white dress on it, are waiting for her arrival.

I return to the kitchen and sit on my wicker chair and look out at the spire of St George's over the rooftops. A pigeon is cleaning its feathers on my windowsill. I try to clear my head of all distracting thoughts. The important thing now is to concentrate.

The doorbell goes and I answer it. I boil the kettle so that the tea will be just ready for Kate when she has climbed all my stairs. I ask her if her journey from her home in Clapham was easy today.

As we drink our tea, we talk about our children. She tells me about her daughter, Molly, now doing a PhD in English at Oxford. I talk to her about Frank and Masha and their children, Eve Pamela and Lawrence Emil, who are aged respectively two and a half and three months and who I try to see regularly: they are living in Cambridge now, in my mother's house where Frank grew up, and which they have made into their home.

Then I go into the studio. I place the painting of Kate, that I started two months ago, onto the easel and I wait for her to put on her 'sitting dress' and to assume her position on the chair in the corner. She enters the studio and sits down. I pick up my brush.

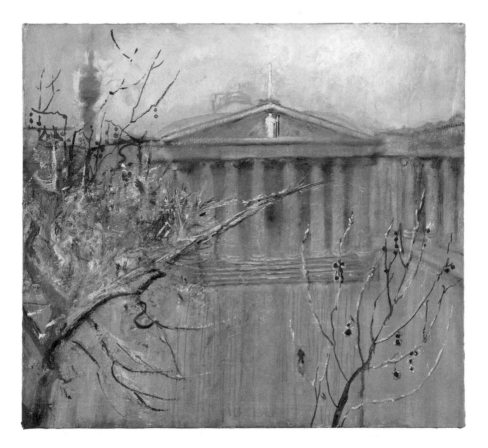

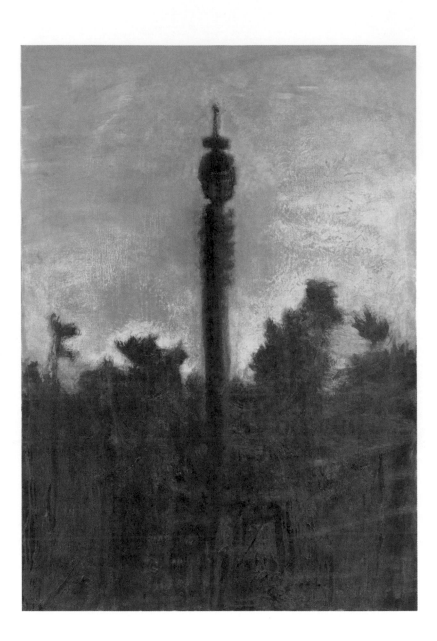

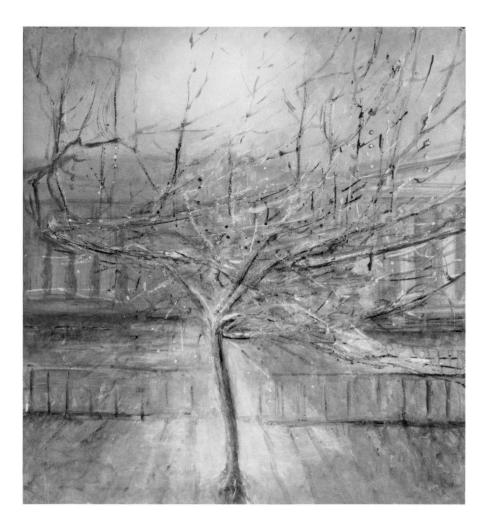

List of Illustrations

p. ii Self-Portrait, 1983 (ink on paper)

p. 6 My Mother and God, 1990 (oil on canvas)

p. 10 Kate in White, 2010 (oil on canvas)

p. 11 Frank and Me, 2011 (oil on canvas)

p. 12 Steve, 2017 (oil on canvas)

p. 13 My Mother, 2007 (oil on canvas)

p. 15 Celia, Lee Abbey, north Devon, 1976 (photograph)

p. 22 Back of My Mother's Knees, 1978 (charcoal on paper)

p. 22 Little Tin Picture, 1980–81 (oil on tin)

p. 23 Kate by the Window, 1987–9 (oil on canvas)

p. 29 Linda Sleeping, 1992 (softground etching)

p. 41 Metamorphosis, 1975 (wood engraving)

p. 43 My First Home, 2016 (oil on canvas)

p. 44 Paul family, Trivandrum, south India, 1963 (photograph)

p. 44 Celia, Trivandrum, 1964 (photograph)

p. 44 Paul sisters, Lee Abbey, Devon, 1974 (photograph)

p. 49 The House Where I Was Born, 2005 (oil on canvas)

p. 51 Lucian Sleeping, 1983 (charcoal on paper)

p. 69 Lucian Sleeping, 1982 (charcoal on paper) / photograph © The Trustees of the British Museum

p. 72 Eugène Delacroix, The Good Samaritan, 1852 (oil on canvas) / © Victoria and Albert Museum, London

p. 72 John Constable, Study for The Leaping Horse, 1825 (detail; oil on canvas) / Victoria & Albert Museum / Bridgeman Images

p. 76 Mother and Kate, 1979 (oil on canvas)

p. 85 Head of Jean, 1993 (hardground etching)

p. 89 Family Group, 1980 (oil on canvas)

p. 91 Steven Kupfer, 1982 (photograph)

p. 95 Dark Night, 2011 (oil on canvas)

p. 98 Lucian Freud, Naked Girl with Egg, 1980 (oil on canvas) / British Council / © The Lucian Freud Archive / Bridgeman Images

p. 102 Lucia, 1981 (charcoal on paper) / photograph © The Trustees of the British Museum

p. 107 Lucian Freud, Interior W11: After Watteau, 1981–3 (oil on canvas) / Private Collection / © The Lucian Freud Archive / Bridgeman Images

p. 108 Lucian and Me, 2019 (oil on canvas)

p. 121 The Brontë Parsonage (with Charlotte's Pine and Emily's Path to the Moors), 2017 (oil on canvas)

p. 125 My Mother with a Necklace, 1982 (oil on canvas)

p. 126 Pamela and Celia, the bishop's house, Bradford, 1982 (photograph)

p. 128 My Mother with a Ring, 1982 (oil on canvas)

p. 129 My Mother with Shining Eyes, 1983 (oil on canvas)

p. 134 Jusepe de Ribera, Jacob's Dream, 1639 (oil on canvas) / Bridgeman Images

p. 134 Rembrant Harmenszoon van Rijn, The Polish Rider, 1655 (oil on canvas) / Bridgeman Images

p. 135 My Mother as St Brigid dreaming, 1983 (oil on canvas)

p. 137 Family Group, 1984–6 (oil on canvas)

p. 139 To Lucian Love Celia (Frank as a newborn baby), 1984 (charcoal on paper) / photograph © The Trustees of the British Museum

p. 141 Pamela with pram, Cambridge, 1985 (photograph)

p. 144 Frank, 10 December 1984 (photograph)

p. 144 Celia and Frank, January 1985 (photograph)

p. 147 Lucian Freud, Girl in a Striped Nightshirt, 1983–5 (oil on canvas) / Tate / © The Lucian Freud Archive / Bridgeman Images

p. 148 Lucian Freud, Painter and Model, 1986–7 (oil on canvas) / Private Collection / © The Lucian Freud Archive / Bridgeman Images

p. 150 Head of Angus, 1984 (charcoal on paper)

p. 151 Angus and Cerith, 1991 (oil on canvas)

p. 155 My Mother with a Rose, 2006 (oil on canvas)

p. 162 Pamela Watts in her Harrow County School uniform, 1938 (photograph)

p. 162 Pamela Watts at King's College, London, 1948 (photograph)

p. 162 Geoffrey Paul and Pamela Watts, 1949 (photograph)

p. 165 My Mother, 2005 (oil on canvas)

p. 167 Mother and Frank, 1990 (oil on copper)

p. 168 Pamela and Frank, Walberswick, 1995 (photograph)

p. 169 Little Walberswick, 1996 (oil on canvas)

p. 170 Mother and Frank 3, 1994 (softground etching)

p. 172 Linda, 1989 (ink and pastel on paper)

p. 173 St Brigid's Vision, 2014–15 (oil on canvas)

p. 175 Last Drawing of My Mother, October 2014 (pencil on paper)

List of Illustrations

p. 177 Clouds and Foam, 2017 (oil on canvas)

p. 178 My Sisters in Mourning, 2015–16 (oil on canvas)

p. 184 Pamela Paul, 2014 (photograph)

p. 185 My Mother and the Sea, 1999 (softground etching)

p. 187 Shoreline, 2015–16 (oil on canvas)

p. 189 Painter and Model, 2012 (oil on canvas)

p. 193 Room and Ghost of British Museum, 2015 (oil on canvas)

p. 194 Self-Portrait, September–October 2015 (oil on canvas)

p. 197 Right panel of diptych: Presence and Absence, 1996 (oil on canvas)

p. 201 Approaching the British Museum, 2009–10 (oil on canvas)

p. 202 Post Office Tower and Plane Tree, 2008 (oil on canvas)

p. 203 Plane Tree in Front of the British Museum, 2014 (oil on canvas)

p. 204 Plane Tree Shadow on my Wall, 2013 (oil on canvas)

p. 205 St George's, Bloomsbury, Early Morning 2013 (oil on canvas)

p. 213 In Front of the Museum, 2008 (oil on canvas)

Acknowledgements

I would like to thank:

My husband, Steven Kupfer, for his unfailing love and support, for his belief in me and for his intuitive response to my work.

My son, Frank Paul, for his love and for his perceptive encouragement. I would also like to thank him and his girlfriend, Masha, and their two children, Eve and Lawrie, for all the joy they bring to my life.

My sister Kate Paul, for all her love and for our deep connection.

My sisters Rosalind Paul, Lucy Archer and Jane Williams, for all their love and kindness.

Sarah Chalfant for her wisdom and guidance and for her inspiring friendship.

Alba Ziegler-Bailey for her conscientious advice and sensitive encouragement.

Victoria Miro for all the confidence she gives me and for the quiet way she looks at my work and for her clear judgement.

Rachel Taylor, Isabelle Young, Hannah van den Wijngaard, Kathy Stephenson at Victoria Miro for their dedication and thoroughness.

Jake Auerbach for his help and insight.

Rivkah Gevinson for her beautiful photographs and for our friendship.

Acknowledgements

Frankie Rossi at Marlborough Fine Art for her generosity and kind help.

Hilton Als for inspiring me to use words again.

Bea Hemming, my editor, with whom I feel very fortunate indeed to work and whose help with this book has been invaluable.

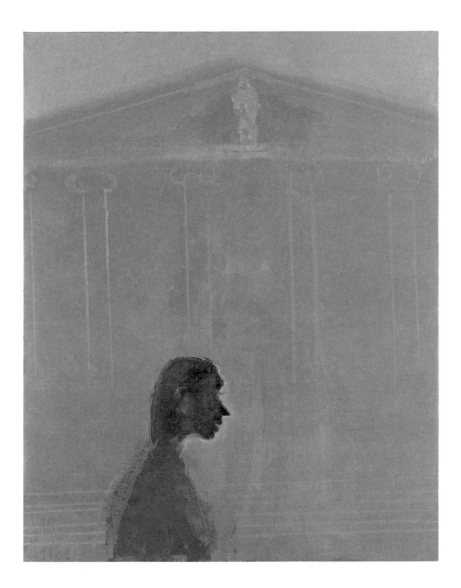